Michael Wilson

EIGHTEENTH-CENTURY FRENCH PAINTING

PHAIDON

Phaidon Press Limited, Littlegate House, St Ebbe's Street, Oxford
Published in the United States of America by E. P. Dutton, New York

First published 1979

ISBN 0 7148 1964 6

Library of Congress Catalog Card Number: 78-24706

Printed in Great Britain by Morrison & Gibb Ltd, Edinburgh

EIGHTEENTH-CENTURY FRENCH PAINTING

To look at eighteenth-century French paintings with an unprejudiced eye is a difficult task. Our response is still conditioned by the attitudes of the last century. Those who regretted the passing of the *ancien régime* recalled it with nostalgia, as an age of elegance, wit and charm. More modern spirits, believers in progress, saw only frivolity, libertinism and indifference to the ills of society. The art of the eighteenth century has always been viewed in the shadow of impending revolution. Consequently all the shifts of taste, style and opinion which distinguish the period before 1789 have been blurred and only the shepherdesses, the powdered wigs and dimpled nudes are remembered.

Even those who hoped to promote French eighteenth-century art contributed to this process. One of the most influential books ever written on the subject is *L'Art au Dix-huitième Siècle* by the Goncourt brothers, published between 1856 and 1875. It reflects throughout the delight of the authors, avid collectors of eighteenth-century art, in the mementos of a past and more aristocratic age. Watteau and Boucher are admired as creators of an exquisitely artificial world. Their art, divorced from the circumstances that contributed to it, offers an unalloyed aesthetic experience, which serves, one feels, to keep the vulgar nineteenth century at bay.

The eighteenth century would have been shocked to hear that its art had nothing to do with reality. Chardin, who depicted simple, everyday scenes, was, after all, one of the most popular artists of his day. But the Rococo too, however artificial it may seem to modern eyes, was a reaction against the grand rhetorical gesturing of baroque painting, which, to the eighteenth century, appeared ludicrous and offensive. Even before the death of Louis XIV in 1715, artists and their patrons had tired of the grand manner as exemplified by Versailles, with its vast allegorical decorations. In the light of new ideas, the myths of absolutist rule, like the dogma of the Church, seemed outrageous. In the last years of the seventeenth century John Locke's *Essay Concerning Human Understanding* had been translated into French, and its practical doctrine, that man's purpose lies in 'a careful and constant pursuit of happiness', runs as a leitmotiv through eighteenth-century art and thought. The principle of rational inquiry, insisted upon by Locke and Voltaire, has its counterpart in art in the growing value placed upon the study of nature – including human nature and society – and upon the individual sensibility.

During the reign of Louis XIV a painter was required to select elevating, heroic themes and treat them according to rules derived from the practice of great masters of the past and from the art of Antiquity. The more learned his allusions to past art, the more esteemed he would be. The spirit of reform is signalled in Antoine Coypel's words to the Academy of Painting early in the century: 'To the solid and sublime beauties of the Antique must be joined the delicacies, the variety, the naivety, and the soul of Nature.' The last quarter of the seventeenth century saw French artists at last responding to the dramatic, exuberant effects of Italian baroque painting, and to the art of Rubens. By 1699, when Roger de Piles, the champion of Rubens and his biographer, was elected to the Academy, the Rubenists had emerged triumphant over the classical followers of Poussin, and young artists were emulating his naturalistic effects and vibrant colour. The art of Rubens, which, with its rapid, spontaneous execution and energetic movement, was diametrically opposed to the meticulously arranged and drawn compositions of French academic art, was invoked in the name of freedom and nature.

As the authority of the Academy and the court slackened, so still-life, portraiture, genre, and the new *fête galante* were able to flourish alongside religious and history

painting, traditionally held to be the most elevated categories of painting. The regular Salon exhibitions held in Paris from 1737 permitted a greater public involvement in contemporary art, which was further aided by reviews and engravings. So the development of painting was no longer dictated by the court alone. Far from being the Goncourts' age of pure aristocratic refinement, the eighteenth century, in France as much as in England, is the first period in which the middle classes left their mark on the arts, encouraging forms which appealed to bourgeois values. The phenomenal success of Chardin and Greuze would have been inconceivable during the reign of Louis XV.

At first glance it might seem that the art of Antoine Watteau (1684–1721) bears no relation to the real world, and completely contradicts the early eighteenth-century desire for a more natural art. His shady woodlands, peopled with elegant couples in costumes of silk and satin, were regarded by the nineteenth century as the poetic fantasies of an invalid, alienated from the society of his age.

It is true that tuberculosis caused Watteau's early death in 1721. And his contemporaries described him as 'always discontented with himself and others'. So far the romantic view holds. Yet, despite his eccentricity, Watteau was supported by a circle of devoted friends who took every opportunity to promote his art. The demand for his work was enormous, and so impressed was the Academy when he presented himself for membership in 1712 that, contrary to custom, he was allowed to choose the subject of his reception piece. Watteau's art may not be realistic but it is far from being the cloyingly sweet and enervated creation described by the Goncourts. For his contemporaries Watteau struck an authentically modern note in ignoring the tradition of history painting and substituting a new genre of his own making, the *fête galante*. This genre conforms to no established rules and is concerned with recognizable emotions, above all with human love.

The ideal world of Watteau's art was not, despite the nineteenth century's assertions, conjured out of thin air. It is derived from the theatre, in particular the Italian Comedy, which, with its irreverent and lively humour, directly challenged the rules of the French classical theatre – an apt basis, therefore, for a non-academic art. Like the theatre, Watteau's make-believe world is an easily grasped metaphor for reality. The *fête galante* was a new allegorical form, but it deals not with heroes and unattainable ideals of virtue and valour, but with situations and emotions common to all men, with, in Locke's words, the 'pursuit of happiness'. As in the theatre, dance and music are symbols for the harmonious union of couples. And in the clown, Gilles or Pierrot, Watteau finds the image of the misfit and the innocent, with which he so much identified.

Watteau's unconventional development was favoured by his origins and training. In 1684 he was born at Valenciennes in eastern France, which shortly before had been part of Spanish Flanders. He was regarded as a Flemish artist, and his roots are principally in seventeenth-century Flemish painting. At an early age he was sketching the rustic characters of his home, very much, one might guess, in the tradition of Teniers and Brouwer. There is nothing aristocratic in Watteau's origins, and on his arrival in Paris in 1702 he was reduced to poorly paid hack-work in a picture factory. His luck changed when he met Claude Gillot, a painter who introduced him to the novel subject of the Italian theatre. The famous company is shown in a late picture by Watteau (Plate 6), taking a final curtain with Gilles in the centre, but it haunts the *fête galante*, even when the characters are not present in familiar guise.

Watteau's settings soon cease to resemble the painted flats of the theatre, literally depicted by Gillot. So too does the emotional breadth of his scenes surpass the limited humour of the Italian Comedy. In *Harlequin and Columbine* (Plate 4), for example, the mystery of the setting and the sophistication of the dress and gestures tell us that the figures are no longer merely play-acting. The vein of deep seriousness stems from the

truth of Watteau's observation of human manners and the subtlety of his paint technique. The evocative colours of his landscapes and the play of light on rich materials show how well he had studied Rubens and Veronese, whose work he saw at the Luxembourg Palace and in the collection of his friend Pierre Crozat.

Watteau was received by the Academy as a painter of *fêtes galantes* when in 1717 he presented the *Pilgrimage to the Island of Cythera* (Plate 3). The subject is drawn from a contemporary play, but it shows no signs of its origin. The evening scene, with its chain of figures, linked in an undulating rococo line, reluctantly leaving the shrine of Venus, is wilfully artificial. But the fading light and the expressions of the few lingering lovers, mingling apprehension and regret, impart a poignant note of seriousness to the festive scene. The levity is underscored by a reminder of the transience of pleasure. All is not artifice in the *Fêtes Vénitiennes* (Plate 5), in which Watteau seems to have portrayed himself, gaunt and haggard, as the rustic bagpipe player who sits at the edge of the company, looking on wistfully as the couple dances. And in the last year of his life, in the shop-sign he painted at his own suggestion for his friend Gersaint, Watteau unexpectedly turns to the contemporary urban scene. In a broader style and on a larger scale than hitherto, he depicts the connoisseurs, galants and ladies of fashion who frequent the picture dealer's shop. Yet even here, in the real world, Watteau probes deeper than appearances. The eloquent postures of the figures suggest that, like actors on a stage, they are involved in a complex emotional plot. Viewed in front of the portraits, mythologies and religious scenes that line the walls, they too look as though they could be acting out some sacred or tragic event. The ambiguity of the theatre remains to the end, as this scene of genre assumes a semi-heroic grandeur.

The fashion for Watteau's work did not survive long. Although the influence of his paintings and drawings, engraved after his death under the direction of his friend Jullienne, was felt by artists throughout the century, he was soon regarded as no more than a painter of charming light-weight pieces. His style was trivialized for decorative purposes. He became the victim of the vogue he had created.

Watteau's work found numerous imitators, amongst them Nicolas Lancret (1690–1743) and Jean-Baptiste Pater (1695–1736), his former pupils, both of whom were extremely popular at court. Pater (Plate 9), like Watteau a native of Valenciennes, was always overshadowed by his master, from whom he borrowed poses and costumes. He reproduces Watteau's hazy atmospheric effects, but without their tonal breadth, and imitates his sumptuous, light-flecked costumes. But his colour is chalky and his handling, in comparison, nervous and sketchy.

Nicolas Lancret is a finer colourist and a more perceptive observer of manners than Pater. Being more naturalistic and humorous than Watteau's, his work has greater affinities with Dutch genre. But, incapable of Watteau's poetry, and lacking the crude vitality of his Flemish prototypes, the refined Lancret cannot avoid becoming insipid. Nevertheless a picture like *La Tasse de Chocolat* (Plate 8), exhibited at the Salon of 1742, succeeds in uniting charming natural observation with superb decorative effects. The easy informality of the family group is echoed by the open-air setting, by the garden brimming with flowers and the glimpse of distant woodland. Quite in line with contemporary thinking, Lancret shows, even in this most characteristic piece of rococo design, that nature is the proper breeding ground for man's finest instincts.

While Watteau disregarded the mainstream of French academic art, the traditional genres of painting continued to flourish. Animal and still-life painting, for example, were practised by François Desportes (1661–1743) and Jean-Baptiste Oudry (1686–1753), both of whom served the crown, depicting the royal animals and recording scenes of the chase. Both were heirs to the specialized form of Rubenism found in the Flemish animal painters Snyders and Fyt. Desportes was trained by a Flemish pupil

of Snyders; Oudry (Plate 11) was a pupil of the portraitist Largillierre, who had trained in Antwerp as a painter of still-life. Their finished works are more polished and purely decorative than those of their Flemish predecessors, but their drawings show a concern for natural appearances that was new in France. Desportes even painted oil sketches out of doors as studies for his landscape backgrounds (Plate 10), which foreshadow Corot in their freshness of vision and freedom of technique.

The Academy, the official authority on the arts and organizer of the Salon exhibitions, continued to assert the traditional hierarchy of genres, which gave pride of place to religious and history painting. The Church and the King still promoted painting of this sort, even if other types were preferred for private consumption. The coveted posts of Director of the Academy and Premier Peintre du Roi fell throughout the century to painters of history, to men such as Antoine Coypel, François Lemoyne, Carle Van Loo and Joseph-Marie Vien, the master of David. Chardin, for example, as a humble painter of still-life and genre, stood no chance of such distinction.

But even the dignified genre of history painting softened under the influence of Rubens and Venetian art. Charles de La Fosse (1636–1716), a pupil of Lebrun, was largely responsible for introducing a freer and more richly coloured manner in decorative painting, and virtually all the major history painters of the beginning of the century were indebted to him.

Rubenism is intrinsic to the work of Charles-Antoine Coypel (1694–1752), Jean-François Detroy (1679–1752), and François Lemoyne (1698–1737), who exhibited together in virtual competition at the isolated Salon of 1725. The fashionable form of decorative painting which they represent treats mythological themes lightly and aims to be graceful rather than elevating. In Lemoyne's *Perseus and Andromeda* (Plate 12), for example, one of the pictures he exhibited in 1725, the epic action is taken merely as a pretext for some decorative foreshortening and the treatment of a pretty nude. Detroy too shows little interest in the dramatic or psychological aspects of history painting. The sketches for the tapestry cartoons on the story of Jason and Medea (e.g. Plate 16) that he produced for the Gobelin factory are painted in a lively, almost flippant manner. Unable to take his epic subject seriously, he reduces it to a burlesque pantomime.

Lemoyne excelled Detroy as a decorative painter, and his brilliant illusionistic ceiling depicting the *Apotheosis of Hercules* in the Salon de la Paix at Versailles won him in 1736 the post of Premier Peintre. He did not hold it long, committing suicide the following year in a fit of insanity, and the type of decoration in which he specialized was to be superseded by small-scale pictures inset in panelling, for private rooms rather than public galleries.

Lemoyne's decorative work, despite its elegance, is the last echo of seventeenth-century grandiloquence. More up to date are Detroy's scenes of fashionable upper-class Parisian life. *The Reading from Molière* (Plate 14) reproduces with minute verisimilitude the décor and dress of the period. There is neither satire nor poetry in this domestic record. Yet the truthfulness of the observation was sufficient to win the esteem of Detroy's contemporaries.

After the purely secular and hedonistic interests of Lemoyne and Detroy, Restout's *Adoration of the Shepherds* (Plate 13) comes as a surprise. But, although the most notable, he is only one of a number of artists through the century who continued to paint religious pictures for churches and religious houses. Trained by his uncle Jouvenet, Jean Restout (1692–1768) perpetuated the austere tradition of seventeenth-century classicism. Remarkable in the rococo epoch are the restraint of his colouring, the dignity of his compositions and the psychological depth of his characterization. His belief that a painter requires 'noble feelings, an elevated mind, an excellent character, to treat his subjects worthily' makes him a forerunner of the revival of morally instructive history painting later in the century.

Decorative painting is dominated in the middle years of the century by François

Boucher (1703–70), but at least as famous at the time was Carle Van Loo (1705–65), one of a celebrated family of painters. Van Loo, like Boucher, was patronized by Madame de Pompadour, the King's mistress, and by Marigny, her brother. He rose to be Director of the Academy and in 1762 was appointed Premier Peintre. It is difficult to account for his huge success, since his manner of painting, much influenced by the Bolognese School, is hard and dry. But he was industrious and attempted every kind of painting – religious, history, decorative and modern genre (Plate 15). He is like a compendium of contemporary fashion, catering for every variety of taste.

Boucher, by far the more talented painter, also produced a wide range of work, but wisely avoided the grand style, to which he – and Van Loo – were so little suited. Although he was the pupil of Lemoyne, his tastes inclined him to more intimate subjects and less elevated effects. Flemish art, particularly the pastoral works of such painters as Berchem and Bloemaert, had a more profound influence on his art than the Italian painting which he saw during his stay in Italy in the late 1720s. Always graceful, Boucher is nevertheless not as formal or strained as his predecessors. He brings new life to decorative painting by attempting less and achieving more.

Boucher is the first artist of the century truly to benefit from Watteau's example. His talent as a draughtsman won him employment as a book illustrator, and early in his career he was involved in engraving Watteau's work for Jullienne. As a draughtsman he not only shares Watteau's delicacy of touch, he also shows a similar sensitivity to nuances of dress, gesture and expression. It is just such notes of naturalism that give life even to his most artificial mythological pieces.

Boucher's work is thoroughly unintellectual. Much of it was intended as décor, and as such, visual effect is more essential than profundity of meaning. Yet the deliberate avoidance of drama, strong emotions or bloody actions is quite in line with the sceptical mood of the Enlightenment. Classical mythology, with its crude morality, could no longer be taken seriously by sophisticated society. Consequently it appears in Boucher's painting in wilfully fanciful terms, merely as the trappings that add charm to his real subject, the female nude. His *Rape of Europa* (Plate 18) is an elaborate charade, more pastoral than mythological. There is no urgency in the 'Rape'. The whole action is relaxed, casual, and in its effortlessness, natural. Another mythological subject, *Venus and Mars surprised by Vulcan* (Plate 17), one of four decorative panels painted in 1754, is more frankly erotic, and the paraphernalia of draperies, cupids and doves clearly serves as embellishment to the sensuous figure of Venus. Even the men, upon whom the farce-like action hinges, are in reality only foils to the woman, their ruddy skin showing to advantage the pearly white of her body.

The underlying truthfulness of Boucher's observation is evident in the *Reclining Girl* (Plate 20), in which the draperies of the boudoir provide sufficient embellishment. His feeling for the subject is expressed here not only by the delicate and faithful rendering of young, soft flesh, but also by the dazzling virtuosity of the composition. A mass of folds and sweeping rococo curves converge on the long line of the girl's back, and yet the pose remains unaffectedly abandoned and natural.

In his landscapes Boucher is not inhibited by ideas about fidelity to nature from transforming his material with art. The blues of his foliage and the frothing forms of the trees are far from natural, and the rustic mills, ruins, bridges and streams are arranged into pleasing rococo groups. Yet in comparison with classical landscape, Boucher's pictures show a real response to humble rural scenery. The *Landscape with a Water-Mill* (Plate 21) is devoted not to any incident from history or mythology, but to nature itself. The few tiny figures – nameless peasants and travellers – are not allowed to disturb the evening silence.

That Boucher employs the devices of art to 'improve' his subject does not mean that he is necessarily contrived. His portraits succeed in appearing informal, while showing their sitters to advantage. He depicts his most celebrated patron, Madame de Pompadour, in a series of wonderfully accomplished portraits, leaning against a

statue with a dog at her side, seated in a wood listening to a song-bird, and reclining indoors with books, music and drawings about her (Plate 22).

Boucher was employed over many years by the crown to provide decorative pictures for royal interiors, tapestry cartoons for the Gobelin and Beauvais factories, and stage designs for royal entertainments. He was awarded pensions and honours and in 1765 became Premier Peintre. But by then his work was under attack. Taste was turning against his morally disengaged outlook at the very time when his powers of invention were flagging. Diderot attacked his Salon exhibits for their depravity, censuring their falseness of expression and colour. 'This man has everything, except truth', he wrote in 1761. Diderot condemned Boucher not for any technical short-comings, but for his failure to elevate his art with moral truths. The tables had turned, and for an artist to win esteem he had in future to prove himself *engagé*.

Jean-Honoré Fragonard (1732–1806) chose to sacrifice honours in order to pursue a style of painting that advanced taste disdained. After 1767 he never again exhibited at the Salon, and when, in 1773, Madame du Barry rejected the decorative panels he had painted for her as out of date, he turned from the court to other patrons. In his old age, after the Revolution, he appeared a relic from another era to those who still knew of him.

Yet Fragonard the painter is not a reactionary who was unable to adapt. He is an individualist who, unmoved by the century's increasing demands for a moral art, chose to follow his own bent. And so, while he represents the last flowering of the rococo, he also foreshadows the Romantic movement. There is a waywardness in his art, a current of energy and wild emotion which completely breaks with Boucher's relaxed and civilized art. The *Psyche* (Plate 19) is one of Fragonard's earliest works, painted in 1753 shortly after he had left Boucher's studio to enter the Ecole des Elèves Protégés, under Van Loo, and it still betrays Boucher's influence. The figures almost fill the canvas, and Psyche, in particular, is modelled on the Venuses of Boucher's art. But the transparency of the draperies and the lively poses already show the way Fragonard was to develop, towards lighter effects and more agile movement.

It was during his stay in Italy that he succeeded in evolving a more personal style. Yet it was the scenery, not the art of Italy that made the greatest impact on him. At the Villa d'Este, which he visited with the Abbé de Saint-Non, an enthusiastic amateur and patron of Fragonard, he made numerous drawings of the overgrown gardens with their statues, fountains and balustrades. The pictures he produced there (e.g. Plate 32) are, however, far from being views. The subject is nature, but seen in a wild, romantic guise, reducing men to mere specks of paint.

After his return to Paris in 1761 he made one grand gesture towards history painting with his huge *Corésus and Callirhoé*, shown at the Salon of 1765. In spite of its success, Fragonard chose in his later career to turn away from serious themes. He excels instead as a painter of small-scale works in which the subject is little more than an excuse for the display of his brilliant technique: portraits, real and imaginary, in sketchily painted fancy costumes; erotic bedroom scenes; pastoral anecdotes; studies of girls (e.g. Plate 35); and, most surprisingly, shadowy interiors with people at work, in which forms are merely hinted at with broad, fluid brushstrokes.

The slightness of Fragonard's works, in size, theme and treatment, is in effect a rebuttal of academic pretensions. And yet he is not all levity. *The Swing* (Plate 34) is overtly flippant and erotic, a beautifully painted dirty joke, but the woodland is nevertheless transformed into a wonderfully enchanted place. And the majestic landscape of the *Fête at Saint-Cloud* of 1775 recalls Watteau in the seriousness of its response to nature.

Boucher and Fragonard are not, however, totally representative of eighteenth-century French painting. The work of Jean-Baptiste Siméon Chardin (1699–1779) reveals a very different side, and the success of his humble genre scenes and still-lifes

proves that the eighteenth century was not indifferent to them. Indeed, works by Chardin were bought by royal and aristocratic collectors, the very patrons of Boucher. It is an indication of the relaxed, undoctrinaire attitude that prevailed until about mid-century, that no need was felt to oppose Chardin's realism to Boucher's artifice. In spite of their obvious differences, the artists have this much in common: they preferred a manner of painting which spoke directly through its visual properties, to an anecdotal or moralizing art. There is a serious and moral basis to Chardin's painting, but it is discreet. The truth of his observation is enough to convey a point.

The circumstances of Chardin's early life are unclear, but it is known that his father was a carpenter and that he trained as a painter of still-lifes. He was received as such by the Academy in 1728 and exhibited regularly at the Salon from 1737. But the pictures he showed were genre scenes, possibly because Oudry still dominated the still-life market. Yet Chadrin's early still-lifes are quite unlike Oudry's polished, ornamental pictures. They show simple kitchen objects, jugs and bowls, in informal arrangements. The world of his art is restricted, but the limited subject-matter is more than compensated for by the intensity with which it is observed.

The roots of his domestic genre scenes lie in seventeenth-century Dutch painting, but Chardin is concerned with more than appearances. Diderot praised the veracity of his work, but more remarkable is the dignity with which he invests humble objects. Menial chores and the familiar routine of family life are ennobled by a subtle process of idealization. Figures at work (e.g. Plate 24) are shown in stately poses, as still as statues. A traditional morality, based on puritan values of order and duty, is conveyed by the gravity of his images. Education too is tacitly praised: a young girl is shown instructing a child without any trace of sentimentality or condescension (Plate 23).

The extraordinary formal qualities of Chardin's art are best seen in the still-lifes he painted after about 1750, ranging from the relatively elaborate *Remains of a Meal* (Plate 26) to pictures as simple as the *Vase of Flowers* (Plate 25). He does not aim to imitate with *trompe-l'oeil* finish the surfaces and textures of his subject. His technique is broad. He builds up his pictures with blocks of solid, grainy paint into grave and dignified structures. Like Poussin, he abstracts from his subject an almost geometric order, in which even the colour conforms to a pre-ordained pattern, brighter hues providing focal points within a largely monochromatic whole. At its extreme, this process results in the simplicity of the *Dish of Peaches* (Plate 27), in a design which isolates the compact pyramid of fruit against a completely empty, velvety-brown ground.

By the time Diderot was extolling the truth of Chardin at the expense of Boucher, taste was in fact turning equally against his discreet, pure art. It was not enough that Chardin was true in his perception of nature; truth and morality had to be demonstrated in actions. And this, to d'Angiviller, the Directeur des Bâtiments under Louis XVI, required *les grands genres* – history painting above all.

The collectors and patrons of art in the eighteenth century who took pleasure in Chardin's scenes of middle-class domestic life and the more modish society pictures of Detroy, also required equally natural and detailed records of themselves. Portraiture follows the same development, away from the formal, impersonal treatment favoured by the court of Louis XIV, towards a greater naturalism, and a concentration on character instead of status.

The famous picture of Louis XIV of 1701 (Plate 1) by Hyacinthe Rigaud (1659–1743) is a formal state portrait concerned exclusively with a legendary concept of kingship. Louis XIV is shown in swaggering posture, draped in a huge ermine cloak which amplifies his figure, in front of a conventional baroque background of column and draperies. It is a magnificent piece of propaganda and, although hard in its finish, derives much of its bravura from Rubens and Van Dyck. The direction portraiture was to take, however, is illustrated by Nicolas de Largillierre's portrait

group (Plate 2), traditionally supposed to show the artist and his family. Largillierre (1656–1746) has placed them in the open air, before a landscape that is, in effect, a tribute to Rubens and the Venetians. The father relaxes after the hunt. The mother listens as her daughter sings. For all their splendid dress, they are shown in their proper guise, out of sight of others, enjoying themselves. Rigaud and Largillierre worked throughout their long careers more or less as rivals, but while Rigaud was employed at court, Largillierre's patrons were largely wealthy Parisians who favoured a less formal type of portrait.

Court portraiture too eventually succumbed to the grace of the rococo, most characteristically in the work of Jean-Marc Nattier (1685–1766). Typical are his portraits of Louis XV's daughters in the guise of classical goddesses, but the convention is adopted chiefly as a means to exploit the natural charms of his sitters. The relaxed and intimate atmosphere of these pictures is quite unlike anything that had yet been seen in French royal portraiture. Indeed, he also produced portraits of the Queen, Marie Leczinska, in modern dress, which are direct, simple and highly sensitive.

Nattier's type of light mythologizing soon, however, fell from fashion and was judged contrived. Posing as a critic of the future, the writer Cochin made fun of the idea of fashionable ladies taming eagles to drink from gold cups (Plate 28). A more naturalistic portraiture was practised in the middle years of the century by Tocqué and Aved, and Nattier's place at court was taken by François-Hubert Drouais (1727–75), who exploited the new cult of simplicity by depicting aristocratic children as beggar-boys and gardeners, a device in its way as artificial as Nattier's mythological dress. His masterpiece is the full-length portrait of Madame de Pompadour (Plate 29), begun in the last year of her life and completed in 1764, after her death. His style of painting is hard and wooden in comparison with Nattier's gracefully fluent manner, but his *Madame de Pompadour* is a magnificently modern image. The sitter is shown at work at a tapestry frame in a room at Versailles. As a record of her environment, her dress and her occupation, it is not only more thorough, it is more thoroughly naturalistic than Boucher's of eight years before (Plate 22). Stylistically it anticipates the clarity of the neoclassical portrait. There is less ornament and a greater sense of space. From here it is a short step to David's *Marquise d'Orvilliers* (Plate 46).

The most famous French portraitist of these years, Maurice-Quentin de La Tour (1704–88), also produced a virtuoso portrait of Madame de Pompadour, which ranks alongside the paintings by Boucher and Drouais. But although his work was in demand at the highest levels of society, he was not, primarily, a court artist. It seems that he was persuaded by the success of the Venetian pastellist Rosalba Carriera, when she visited Paris in 1720–21, to take up pastel, and throughout his long career he worked almost exclusively in that medium, achieving a peak of technical accomplishment that has scarcely ever been matched. He almost invariably adopts a small, bust-length format and shows his sitter against a plain background. He dispenses with all unnecessary accessories and concentrates attention on his astonishingly lifelike heads. Like Chardin, he seemed to his contemporaries a kind of magician, capturing the living presence of his subjects, without any of the adornments of art.

Something of the nature of the artist – witty, eccentric, satiric, and in his last years mentally unstable – can be gauged from his self-portrait (Plate 30). It was as much by virtue of his unconventional character as his art that La Tour so much over-shadowed Jean-Baptiste Perronneau (1715?–83), also a gifted portraitist in pastel. Perhaps because of La Tour's dominance in Paris, Perronneau spent much of his working life in Italy, Russia and Holland, where he died. His pastel technique differs from La Tour's in being less highly polished, but perhaps, for that, is more forceful. He rarely flatters his sitters, and the grainy texture of his drawing lends a toughness to his portrait heads, which are nevertheless highly convincing as likenesses. Unlike La Tour, he also excelled in oils, and in his portrait of the writer Jacques Cazotte

(Plate 31), possibly his masterpiece, his sure grasp of character is matched by the skill with which he reproduces the texture of skin, lace and satin.

It is surprising, in view of the eighteenth century's interest in nature and its rejection of the grandiose public manner of baroque art, that it produced so few painters of landscape. Watteau's parklands and Boucher's pastorals are essentially the extension of highly personalized artistic worlds. The urban society of Paris was more concerned with human nature. Yet the middle years of the century saw the success at the Salon of Claude-Joseph Vernet (1714–89), who, with Chardin and La Tour, won the admiration of Diderot as a truthful painter of nature. He was commissioned by the King in 1756 to produce a series of large pictures representing the French ports '*au naturel*', but his most characteristic work is, in fact, more fanciful and less precise in its setting. For seventeen years he lived in Italy, and the rocky Italian coastline haunts his paintings. In some (e.g. Plate 36) he imitates Claude's luminous skies and enlivens the foreground with animated groups of fishermen, washerwomen and fashionably dressed sightseers. In others, closer to Salvator Rosa, he depicts storms and shipwrecks, which anticipate the Romantic preoccupation with the wild and sublime forces of nature.

Vernet illustrates, in his combination of the decorative, the natural and the violent, the conflicting preoccupations of French art after 1750. A similar blend of moods occurs in the paintings of Hubert Robert (1733–1808). Like Vernet, he was inspired by the Italian landscape, but rather by rugged mountain scenery and by the ruins of ancient Rome. He is principally a decorative painter, producing countless capriccios of ruins that are much indebted to Panini. But he combines fanciful invention in his architectural arrangements with a real feeling for atmospheric effects. And there is a grandeur in his evocation of a vanished civilization which links him with the more serious adherents of neoclassicism (Plate 37). Robert's light, sketchy manner closely resembles the style of Fragonard, with whom he worked during his early years in Italy. It lends an air of spontaneity even to his most naturalistic scenes. In his late views of Paris he is by no means painstakingly faithful in his recording of the contemporary scene, but achieves, instead, the freshness and immediacy of an eye-witness account.

A different and less modern impression of Paris is given by Gabriel-Jacques de Saint-Aubin (1724–80), best known for his engravings and his sketches of the Salon exhibitions. His surviving paintings – portraits, projects for decorations, and various types of genre – nevertheless show a lively execution and a real talent for observation. In his *Street Show* (Plate 38), however, he sacrifices detail for decorative effect. The elegant spectators, echoes of Watteau's *fêtes galantes*, and tall, arching trees, are seen broadly silhouetted against the sun-bathed street scene. Yet the vigorous drawing and exaggerated gestures, verging on caricature, succeed in conveying the animation of the crowded scene, in a manner that anticipates Daumier's pictures of Parisian life a century later. Like Daumier, Saint-Aubin delights in the crude melodrama of the popular theatre, and in such life-like touches as the sleeping boy astride a bass drum.

This delightful and indulgent view of life, this appetite for colour and movement – almost for their own sake – was not to survive. The change is signalled in Diderot's famous appeal to the artist: 'First of all move me, surprise me, rend my heart; make me tremble, weep, shudder, outrage me; delight my eyes afterwards if you can.' The dilution of traditional religious and history painting left a void which could not be filled by decorative art. Although the eighteenth century was sceptical about conventional religious morality, it still required painting to provide moving and instructive examples of virtuous behaviour. And in the secular spirit of the period, the two were largely synonymous: to feel oneself virtuous was to be virtuous. The dependence upon emotion as a guide, rather than reason, had been encouraged by the writings

of Jean-Jacques Rousseau as part of his cult of nature, and by the sentimental novel. Man in his natural state was, so it was believed, essentially good. Society had perverted him. Thus he needed to return to a state of simplicity and be directed by his natural emotions.

Thus Diderot castigated Boucher's depraved and lying art. The falsities of the rococo were rejected and an unsophisticated simplicity was affected in dress, behaviour and painting. The portraits of Louise-Elisabeth Vigée-Lebrun (1755–1842), Marie-Antoinette's favourite painter, illustrate well the new vogue. Her aristocratic sitters adopt the dress and coy manners of country girls. They dissimulate their cultivated breeding, and swoon with emotion at the beauty of their voices (Plate 43).

Diderot's hero and the most famous exponent of sensibility and moral instruction in painting is Jean-Baptiste Greuze (1725–1805). His realistic genre scenes satisfied the public demand for an anecdotal art that would tell moving stories of domestic piety and filial devotion, and confirm the sentimental belief that where the heart ruled, virtue and happiness reigned. Therefore, although he was a fine portraitist capable of strong naturalistic observation (e.g. Plate 42), his typical genre pieces depend not upon psychological perception, but upon the presentation of simple, recognizable emotions in melodramatic *tableaux vivants*.

The picture that consolidated his fame was *The Village Betrothal* (Plate 40), which was exhibited at the Salon of 1761. It shows a family, arranged as though on a stage, witnessing the betrothal of the daughter. After the amorous escapades of rococo art, youthful love is now legitimized by legal bond and the consent of the parents. It confirms, therefore, orthodox, bourgeois values. Nevertheless, Greuze exploits the situation to its limits by dramatizing the scene with exaggerated gestures and expressions.

The heightened emotionalism of pictures like *The Village Betrothal* and the realistic description of characters and setting won Greuze a large and enthusiastic audience. But the morality of these works is only surface-deep. Greuze's painting is like journalistic scandal which allows a complacent public to feel itself virtuous while it relishes the poignant or savoury aspects of a story. This is especially true of the pictures of tender, adolescent girls, swooning with emotion over a pet dog or dove, or tearfully lamenting a basket of broken eggs or a smashed mirror. The sexual innuendo is obvious. The sensationalism of the pictures invites the impressionable spectator to indulge in erotic fancies.

Greuze successfully exploited the cult of sensibility, but as taste turned in favour of more heroic themes and a sterner morality, so his work fell from favour. Domestic themes were insufficient. A type of painting was required, particularly after the succession of Louis XVI in 1774, that would elevate public morality with depictions of patriotic self-sacrifice and heroic magnanimity. The Comte d'Angiviller, Louis XVI's Directeur des Bâtiments, seeking to regenerate painting, commissioned a series of large history pictures for a proposed national museum in the Louvre. The majority treat subjects from French history. François-André Vincent (1746–1816), for example, contributed *President Molé stopped by Insurgents during the Fronde*, and in 1783 he was honoured with another important royal commission, to produce a series of pictures illustrating incidents from the life of the French King Henry IV, as cartoons for Gobelin tapestries (Plate 39).

As artists sought themes from history that were morally instructive, so they needed a style commensurate to their aims. And as their moral exempla were true, so their chosen style eschewed the false, illusionistic effects of baroque art. Nature was once again invoked as a guide, but nature as interpreted by the art of Antiquity: idealized, ennobled, perfected. The excavations at Pompeii and Herculaneum in 1748 had awakened new interest in Antique art, and since the middle of the century artists in Rome of all nationalities had been adopting a more classical manner. The German

theorist Johann Winckelmann had written in praise of the 'noble simplicity' and 'calm grandeur' of Greek and Roman art, and advocated a style that was linear, static, and subdued in its colouring, in imitation of classical sculpture. Poussin, as an artist whose style had been founded on Antique art, was once again adopted as a model by painters, and ironically one of the first French painters to make use of his art was Greuze. In his later genre pieces, such as *The Punished Son* (Plate 41) of 1778, he arranges his figures against an empty background, in imitation of a classical frieze. At the Salon of 1769 he even exhibited an Antique subject painted in the modern neoclassical manner, an historical variation on the father and son theme: *Septimus Severus rebuking his son Caracalla*.

The rage for things Antique affected more than style. Subjects from classical history and the epic literature of Homer became increasingly popular, but treated now with archaeological exactitude. Artists took every opportunity to display their knowledge of Antique dress and architecture. The results were usually either pedantic or banal: lugubrious death scenes, stiff and oppressive in their 'calm grandeur', or trivially pretty pieces with decorous Greek ladies assembled for a bath. The painter who did more than anyone to popularize the new style in France was Joseph-Marie Vien (1716–1809), but his insipid works remain rococo in sentiment. His popularity was a result of just this. He presented his fashionable clientèle with affecting or semi-erotic themes in a modish Greek wrapping. It takes little to see that his chaste-looking maidens are the direct descendants of Boucher's more honest, if more brazen, nymphs.

Only with the advent of David did the neoclassical movement produce serious works of art with relevance to the period. Yet the decorative, lightly mythologizing vein, apparent through the century, did not entirely die out. Pierre-Paul Prud'hon (1758–1823) succeeded where Vien did not in fashioning out of the classical idiom a genuinely sensuous and evocative art. The proportions of his figures in *The Union of Love and Friendship* (Plate 47) depend upon classical sculpture, but the contours are softened and the velvety light creates a mysterious play of shadows. Correggio and Leonardo da Vinci are at least as important to his work as Antique art. To the late eighteenth century his enchanting, unreal allegories must have seemed strangely backward-looking, but he was valued for his talents as a vignettist and illustrator, and after the turn of the century worked for the Imperial Court. His moving portrait of the Empress Josephine seated in a wood shows the Romantic in Prud'hon, and his work was in fact to inspire Géricault and Delacroix, the artistic rebels of the nineteenth century.

Prud'hon even won the regard of David, alien though his art is to the martial and masculine ethos of David's work. It was Jacques-Louis David (1748–1825), the pupil of Vien, who succeeded in transforming neoclassicism from a fashionably archaeologizing style into an art form that spoke to the present. He infuses the forms with serious patriotic emotion, and his natural vitality and strength of feeling are given direction and edge by the strict discipline of the style, not hampered by it.

David's passionate nature early inclined him towards baroque effects, and he showed no interest in the modern style. His first efforts at history painting are the successors to Boucher's and Fragonard's spirited visions of the past. The flamboyant gestures, colourful settings and rapid, painterly execution all defy the precepts set down by Winckelmann. When, after winning the Prix de Rome in 1774, he went to study in Italy, he declared that the Antique lacked action and would not seduce him. But impressionable by nature, he returned to Paris a convert, and the *Belisarius receiving Alms*, which he exhibited at the Salon of 1781, is an exercise in the laconic, moralizing vein of Poussin.

The *Belisarius* was praised by Diderot for its noble style, but, since he died in 1784, Diderot never lived to see the picture which, above all others, fulfilled his exhortation 'to paint as they spoke in Sparta'. *The Oath of the Horatii* (Plate 44) is the first painting

to meet his demands for a serious, heroic art, at once moral and passionate. It caused a sensation at the Salon of 1785. Although the picture was commissioned for the King, the fanatical and violent devotion of the three brothers to the fatherland gave it Republican and revolutionary significance. The Horatii swear to die, if necessary, in the defence of Rome, ignoring the distress of their sisters in their manly fervour.

Such cruel and extreme emotion is quite foreign to neoclassical canons. So also is the stark realism of David's image. The sombreness of the colour (relieved only by the strident red of the costumes), the emptiness of the bare walls, and the uncompromising stance of the men breaks not only with the rococo, but with the academic historicism of the classical revival too. David strips away all unnecessary accessories and fastens on physical facts. It is the visual expression of moral certainty.

It was this unquestioning faith in truth and reform that qualified David to be the painter of the Revolution. And when, with the events of 1789, the ideals of the *Horatii* seemed to become reality, the events of the present took on the heroic resonance of the ideal. David played an active part in the Revolution, served as a Deputy, organized festivals in honour of the new Republic, and abolished the Academy, the hateful artistic tyrant of the *ancien régime*.

David's belief in the present inspires his works in these years with an urgency quite untrammelled by convention. His portrait of the *Marquise d'Orvilliers* (Plate 46) is arresting in its simplicity and in its concentration on the plump, almost homely, face of the sitter. The matter-of-fact way in which the paint is applied reflects David's single-minded purpose and his refusal to be seduced by the medium. By nature he is not an imaginative painter. His power lies rather in the strength of his emotional response to things as seen. After the fall of Robespierre in 1794 he was imprisoned in the Luxembourg Palace, from where he painted the astonishing view of the gardens (Plate 45), which, in its novel composition and absence of story or moral, sweeps away all the conventions of eighteenth-century painting.

David also invented the modern history painting, inspired by the present and not the past. In 1793 the Jacobin leader Marat was murdered in his bath by Charlotte Corday. David himself had visited Marat the day before and he drew on first-hand experience when he decided to paint the dead hero (Plate 48). But the tautness of the composition prevents the realistic details from becoming merely prosaic. The dark, empty background draws attention to the slumped figure of the revolutionary martyr, while the austere, almost abstract simplicity of the foreground objects dignifies them. The event is at once poignantly real, and elevated above common experience. As Baudelaire wrote in 1846, 'as cruel as nature, this picture has all the perfume of the ideal'.

There is briefly in David's art a meeting of real and ideal. He brings together momentarily the conflicting strains of the century, the spontaneity, the naturalness and the immediacy that run from Watteau to Fragonard, and the moral, the instructive and the noble to which history painting had aspired. The balance could not last. The years of political conviction passed, and, as Napoleon's painter, David had to resort to traditional methods of glorifying the hero. His work becomes less real, less vigorous and more fastidiously classical. And so paradoxically the opponent of the Academy became the founder of nineteenth-century academicism. But as the painter of *The Dead Marat* David inaugurated the Romantic age. Gros, Géricault and Delacroix, the champions of the new movement, looked back once more to the example of Rubens, and, like their counterparts a century before, fashioned an art dependent on broad, painterly effects and sensuous colour. Yet their vision had been conditioned by David's modern heroic works. He had made possible the serious treatment of contemporary themes. He had championed the liberty of the artist, opened the Salon to all, and, with no regret for the vanished past, had addressed himself to the present age.

Select Bibliography

Friedlaender, W., *David to Delacroix*, Cambridge, Mass., 1952.
Goncourt, J. and E., *L'Art au Dix-huitième Siècle*, Paris, 1880–82.
Levey, M., and Kalnein, W. G., *Art and Architecture of the Eighteenth Century in France*, London, 1972.
Levey, M., *Rococo to Revolution*, London, 1966.
Rosenblüm, R., *Transformations in Late Eighteenth-Century Art*, Princeton, 1967.
Thuillier, J., and Châtelet, A., *French Painting: From Le Nain to Fragonard*, Geneva, 1964.

Works on Individual Artists
Ananoff, A., *Boucher: Peintures*, 2 vols., Lausanne and Paris, 1976.
Brookner, A., *Greuze: The Rise and Fall of an Eighteenth-Century Phenomenon*, London, 1972.
Brookner, A., *Watteau*, London, 1967.
Delécluze, M. E. J., *Louis David, son école et son temps*, Paris, 1855.
Rosenberg, P., *Chardin*, Geneva, 1964.
Wakefield, D., *Fragonard*, London, 1976.

List of Plates

72·4 × 90·8 cm. Collection of the Dowager Marchioness of Cholmondeley.

15. CARLE VAN LOO (1705–65): *Halte de Chasse.* 1737. Canvas, 220 × 250 cm. Paris, Musée du Louvre.

16. JEAN-FRANÇOIS DETROY (1679–1752): *Jason Swearing Eternal Affection to Medea.* 1742–3. Canvas, 56·5 × 52·1 cm. London, National Gallery.

17. FRANÇOIS BOUCHER (1703–70): *Venus and Mars surprised by Vulcan.* 1754. Canvas, 166 × 85 cm. London, Wallace Collection.

18. FRANÇOIS BOUCHER (1703–70): *The Rape of Europa.* 1747. Canvas, 160·5 × 193·5 cm. Paris, Musée du Louvre.

19. JEAN-HONORÉ FRAGONARD (1732–1806): *Psyche showing her Sisters her Gifts from Cupid.* 1753. Canvas, 168·3 × 192·4 cm. London, National Gallery.

20. FRANÇOIS BOUCHER (1703–70): *Reclining Girl.* 1752. Canvas, 59 × 72·9 cm. Munich, Alte Pinakothek.

21. FRANÇOIS BOUCHER (1703–70): *Landscape with a Water-Mill.* 1743. Canvas, 90·8 × 118·1 cm. Co. Durham, Barnard Castle, The Bowes Museum.

22. FRANÇOIS BOUCHER (1703–70): *Madame de Pompadour.* 1756. Canvas, 201 × 157 cm. Munich, Alte Pinakothek.

23. JEAN-BAPTISTE SIMÉON CHARDIN (1699–1779): *The Young Schoolmistress.* 1740. Canvas, 61·6 × 66·7 cm. London, National Gallery.

24. JEAN-BAPTISTE SIMÉON CHARDIN (1699–1779): *The Scullery Maid.* 1738. Canvas, 45·7 × 36·9 cm. Glasgow University, Hunterian Collection.

25. JEAN-BAPTISTE SIMÉON CHARDIN (1699–1779): *A Vase of Flowers.* About 1761. Canvas, 43·8 × 36·2 cm. Edinburgh, National Gallery of Scotland.

26. JEAN-BAPTISTE SIMÉON CHARDIN (1699–1779): *The Remains of a Meal.* 1763. Canvas, 38 × 46 cm. Paris, Musée du Louvre.

27. JEAN-BAPTISTE SIMÉON CHARDIN (1699–1779): *A Dish of Peaches.* 1758. Canvas, 37·5 × 46 cm. Winterthur, Oskar Reinhart Collection.

28. JEAN-MARC NATTIER (1685–1766): *The Duchess of Orléans as Hebe.* 1744. Canvas, 131 × 105 cm. Stockholm, National Museum.

29. FRANÇOIS-HUBERT DROUAIS (1727–75): *Madame de Pompadour.* 1763–4. Canvas, 217 × 156·8 cm. London, National Gallery.

30. MAURICE-QUENTIN DE LA TOUR (1704–88): *Self-Portrait.* About 1760. Pastel, 64 × 53 cm. Musée d'Amiens.

31. JEAN-BAPTISTE PERRONNEAU (?1715–83): *Jacques Cazotte.* About 1760–64. Canvas,

32. JEAN-HONORÉ FRAGONARD (1732–1806): *The Gardens of the Villa d'Este, Tivoli.* 1760. Canvas, 37 × 46 cm. London, Wallace Collection.

33. JEAN-HONORÉ FRAGONARD (1732–1806): *The Bolt.* About 1779. Canvas, 73 × 93 cm. Paris, Musée du Louvre.

34. JEAN-HONORÉ FRAGONARD (1732–1806): *The Swing.* 1768–9. Canvas, 83 × 66 cm. London, Wallace Collection.

35. JEAN-HONORÉ FRAGONARD (1732–1806): *Woman Reading a Book.* About 1775. Canvas, 82 × 65 cm. Washington D.C., National Gallery of Art.

36. CLAUDE-JOSEPH VERNET (1714–89): *View over a Bay.* About 1742. Canvas, 57 × 105 cm. London, Wellington Museum.

37. HUBERT ROBERT (1733–1808): *Architectural Capriccio with Temple and Obelisk.* 1768. Canvas, 106 × 139 cm. Co. Durham, Barnard Castle, The Bowes Museum.

38. GABRIEL-JACQUES DE SAINT-AUBIN (1724–1780): *A Street Show in Paris (La Parade du Boulevard).* 1760. Canvas, 80 × 64·1 cm. London, National Gallery.

39. FRANÇOIS-ANDRÉ VINCENT (1746–1816): *Le Rendez-vous (Henri IV and Gabrielle d'Estrées).* 1783–7. Canvas. Musée de Fontainebleau.

40. JEAN-BAPTISTE GREUZE (1725–1805): *The Village Betrothal.* 1761. Canvas, 92 × 117 cm. Paris, Musée du Louvre.

41. JEAN-BAPTISTE GREUZE (1725–1805): *The Punished Son.* 1778. Canvas, 130 × 163 cm. Paris, Musée du Louvre.

42. JEAN-BAPTISTE GREUZE (1725–1805): *Portrait of Edouard-François Bertin.* About 1800. Panel, 46 × 36 cm. Paris, Musée du Louvre.

43. LOUISE-ÉLISABETH VIGÉE-LEBRUN (1755–1842): *Madame Grand, later Princesse de Talleyrand.* 1783. Canvas, 92 × 72·4 cm. New York, Metropolitan Museum of Art.

44. JACQUES-LOUIS DAVID (1748–1825): *The Oath of the Horatii.* 1784. Canvas, 330 × 425 cm. Paris, Musée du Louvre.

45. JACQUES-LOUIS DAVID (1748–1825): *View in the Luxembourg Gardens.* 1794. Canvas, 55 × 65 cm. Paris, Musée du Louvre.

46. JACQUES-LOUIS DAVID (1748–1825): *The Marquise d'Orvilliers.* 1790. Canvas, 131 × 98 cm. Paris, Musée du Louvre.

47. PIERRE-PAUL PRUD'HON (1758–1823): *The Union of Love and Friendship.* 1793. Canvas, 146 × 113 cm. Minneapolis Institute of Arts.

48. JACQUES-LOUIS DAVID (1748–1825): *The Dead Marat.* 1793. Canvas, 165 × 128 cm. Brussels, Musées Royaux des Beaux-Arts de Belgique.

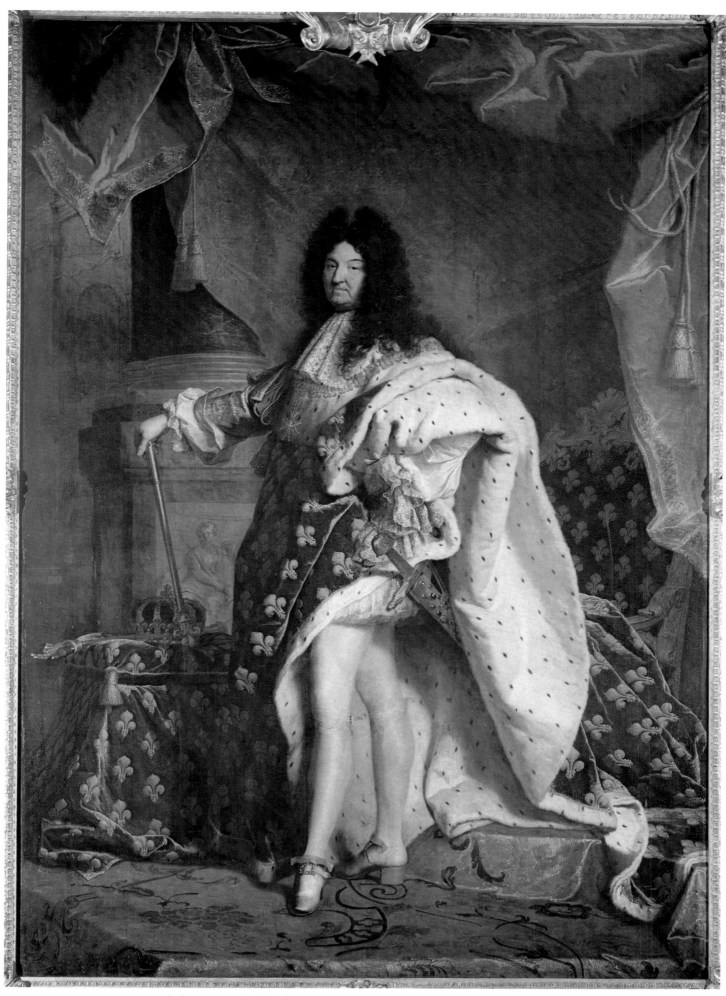

1. HYACINTHE RIGAUD (1659–1743): *Louis XIV*. 1701.
Paris, Musée du Louvre.

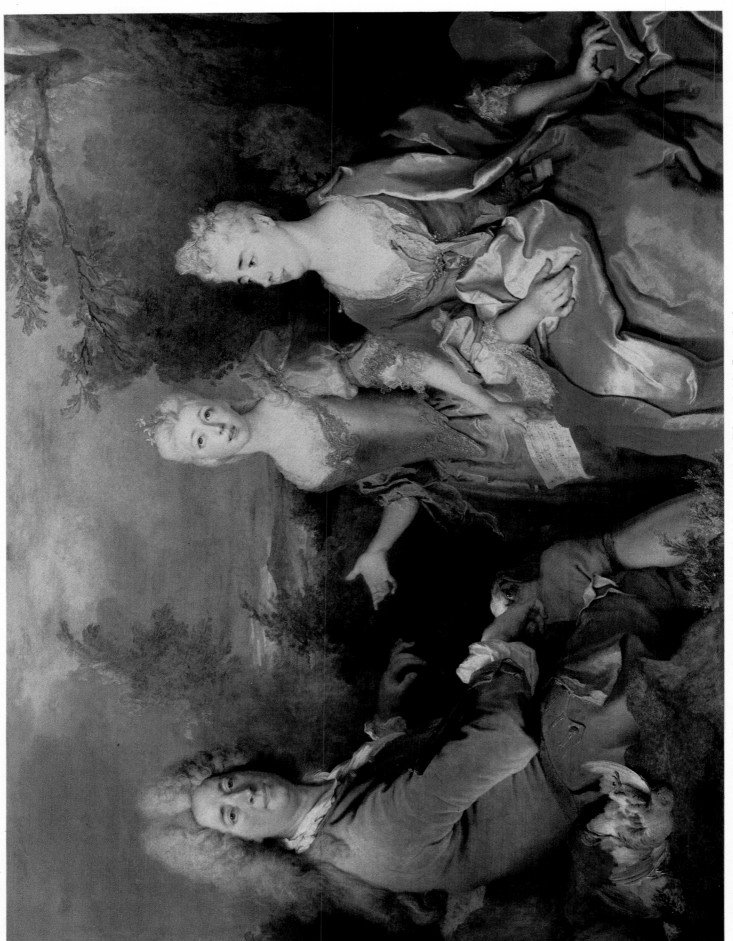

2. NICOLAS DE LARGILLIERRE (1656–1746): *Family Group (The Painter, his Wife and his Daughter)*. Paris, Musée du Louvre.

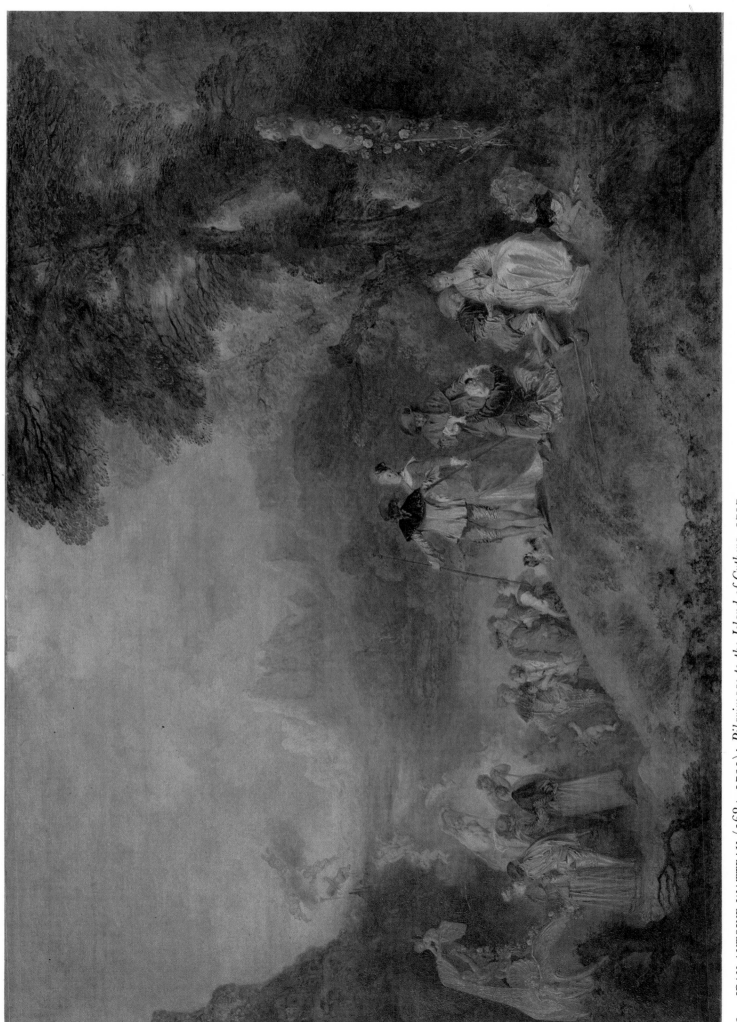

3. JEAN-ANTOINE WATTEAU (1684–1721): *Pilgrimage to the Island of Cythera*. 1717.
Paris, Musée du Louvre.

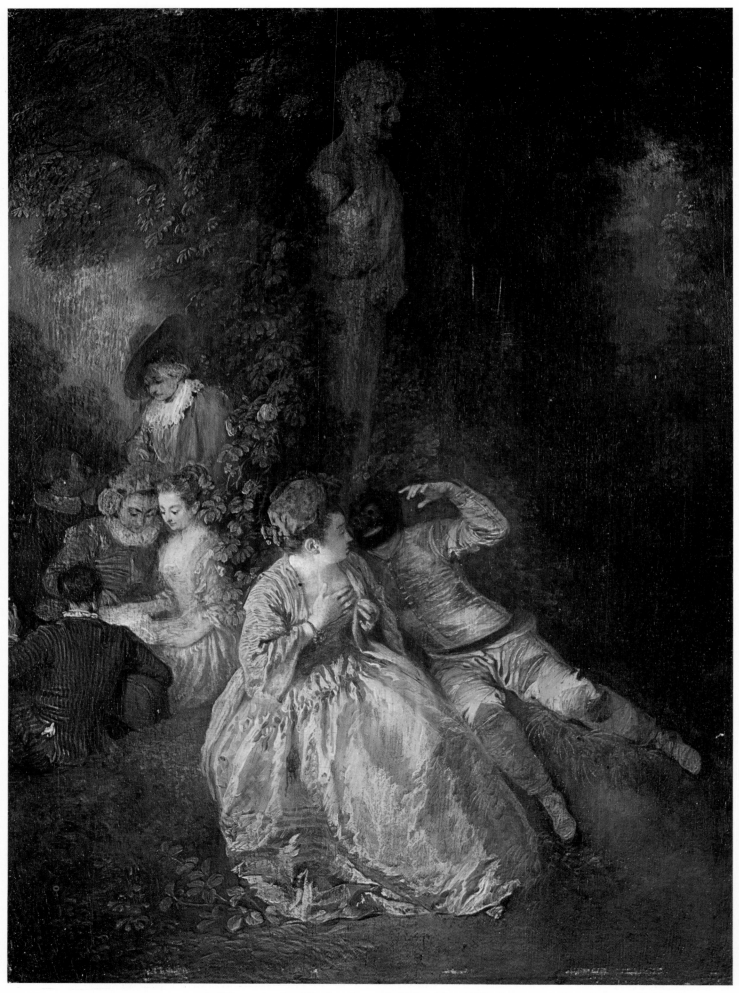

4. JEAN-ANTOINE WATTEAU (1684–1721): *Harlequin and Columbine* ('*Voulez-vous triompher des Belles?*').
About 1716. London, Wallace Collection.

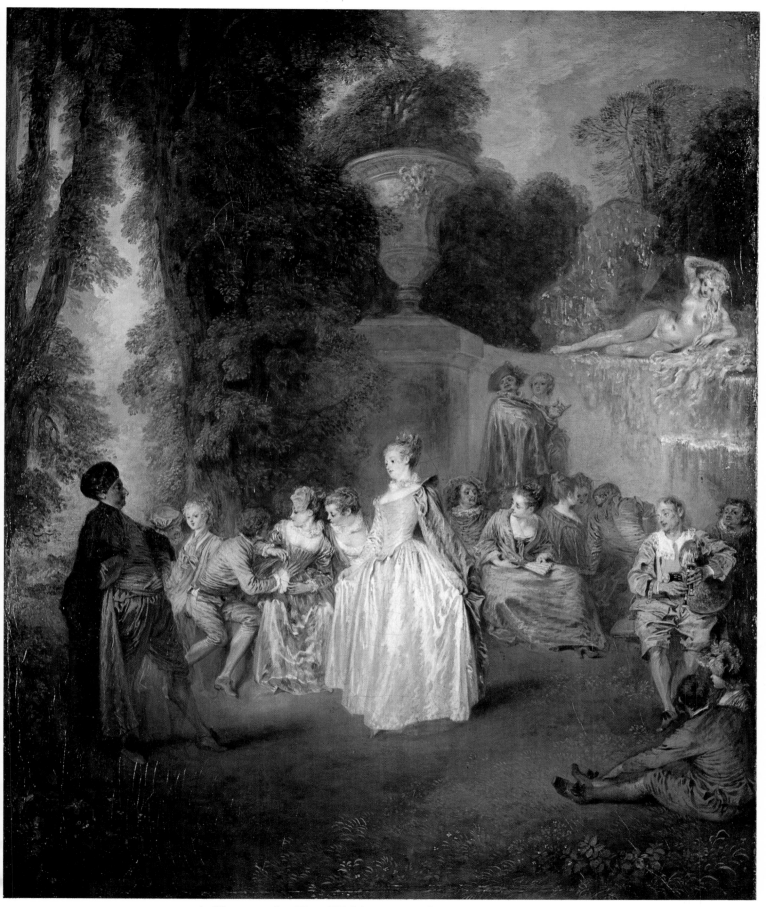

5. JEAN-ANTOINE WATTEAU (1684–1721): *Fêtes Vénitiennes*. 1718–19.
Edinburgh, National Gallery of Scotland.

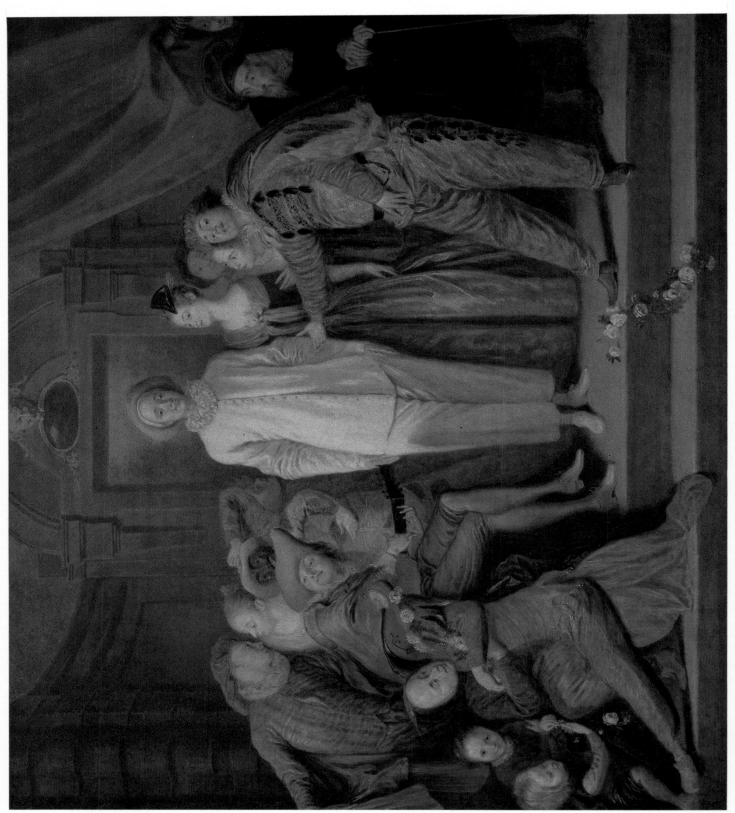

6. JEAN-ANTOINE WATTEAU (1684–1721): *The Italian Players*. 1720.
Washington D.C., National Gallery of Art, Samuel H. Kress Collection

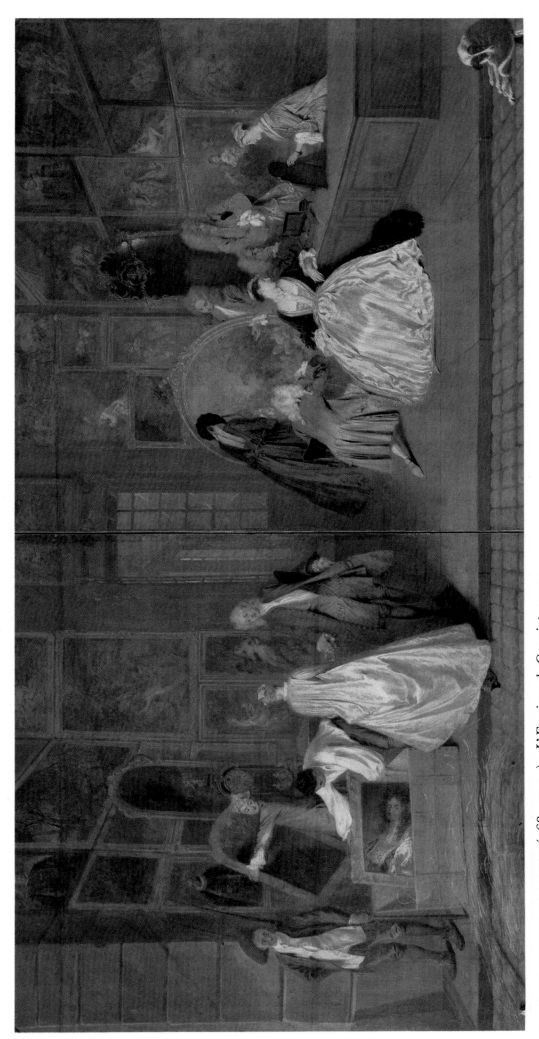

7. JEAN-ANTOINE WATTEAU (1684–1721): *L'Enseigne de Gersaint.* 1721.
Berlin-Dahlem, Staatliche Museen, Gemäldegalerie.

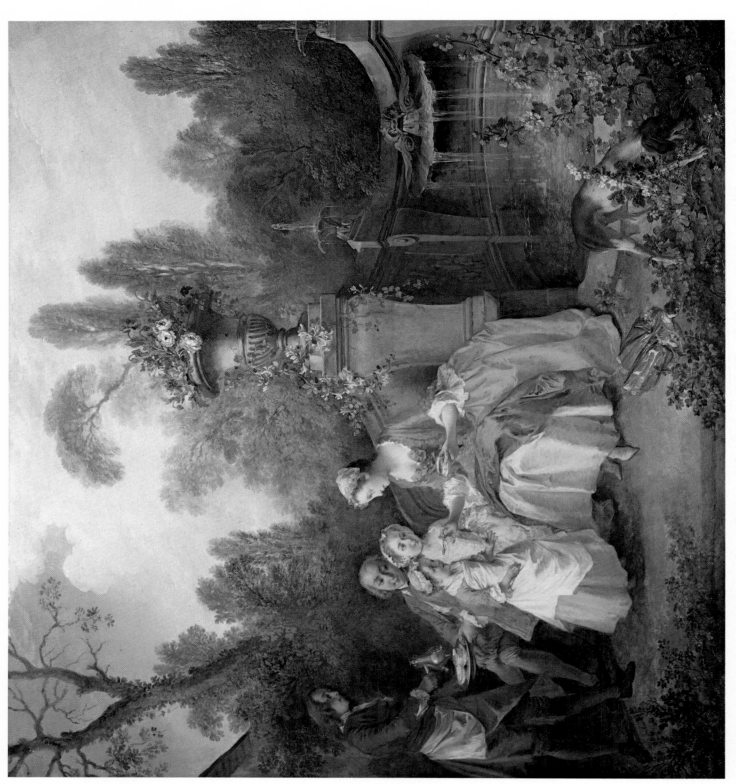

8. NICOLAS LANCRET (1690–1743) : *A Lady and Gentleman with Two Girls in a Garden (La Tasse de Chocolat).* 1742.
London, National Gallery.

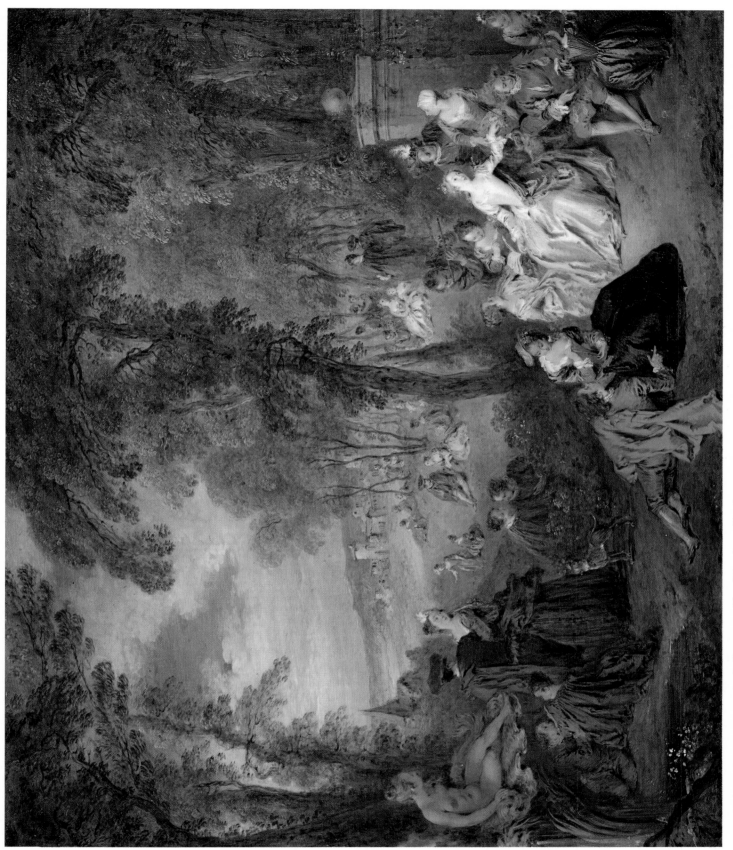

9. JEAN-BAPTISTE PATER (1695–1736): *Fête in a Park.*
London, Wallace Collection.

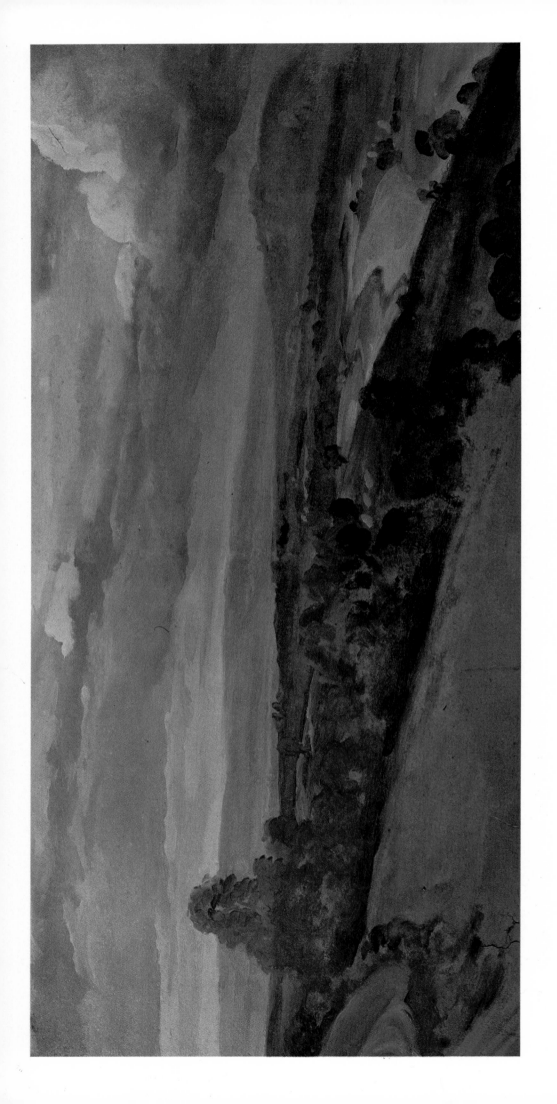

10. ALEXANDRE-FRANÇOIS DESPORTES (1622–1743) : *Landscape.*
Musée National du Palais de Compiègne.

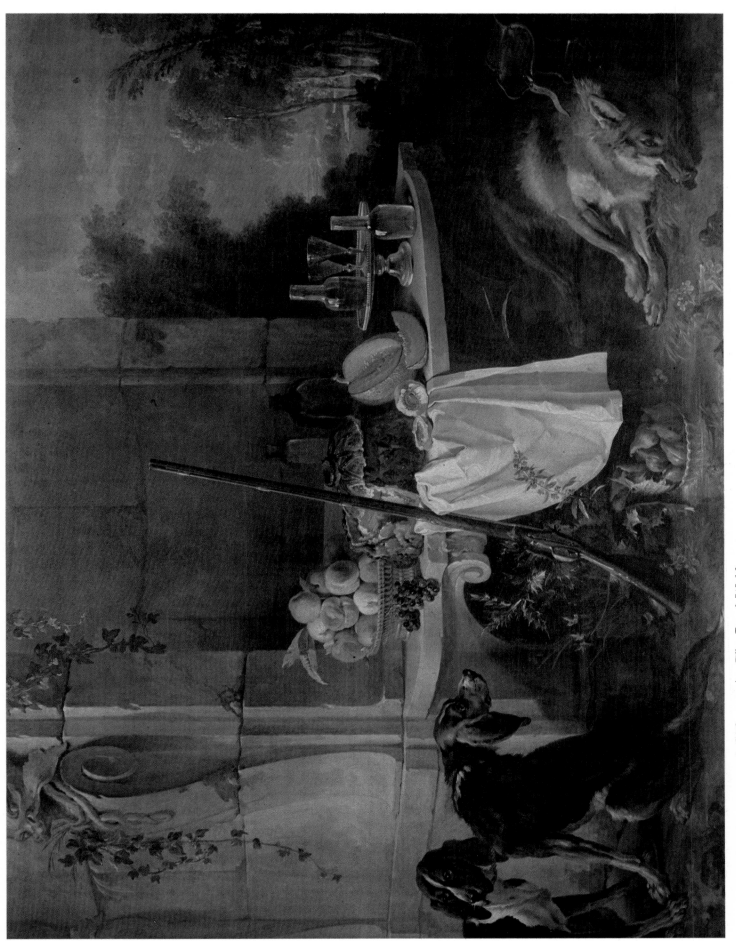

11. JEAN-BAPTISTE OUDRY (1686–1755): *The Dead Wolf.* 1721. London, Wallace Collection.

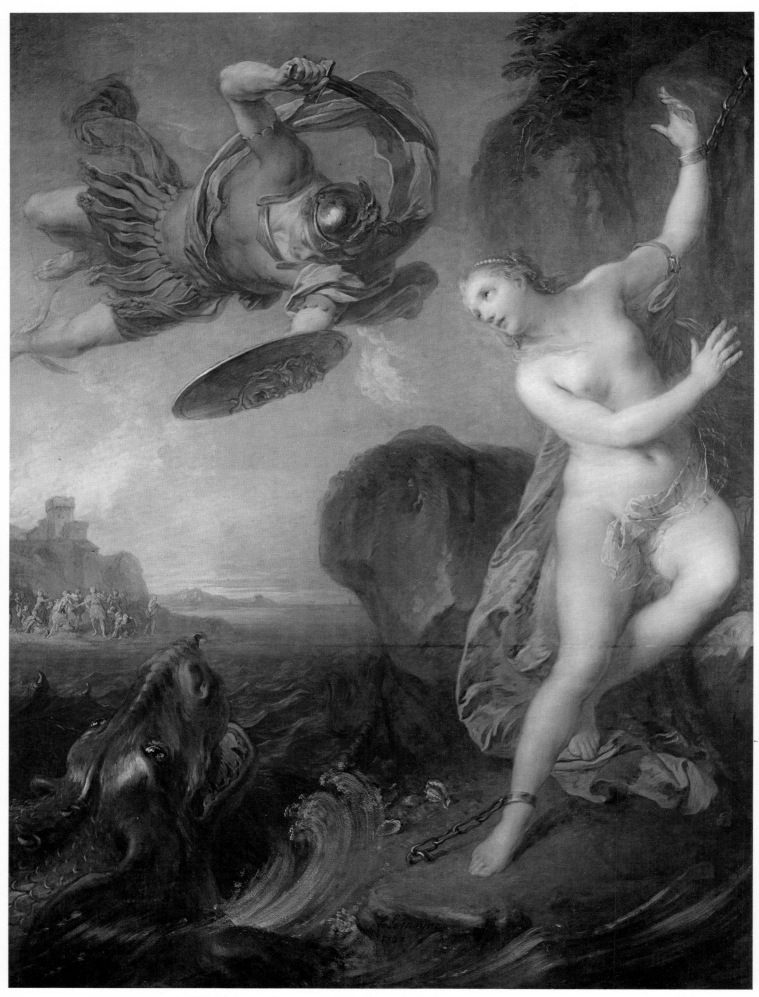

12. FRANÇOIS LEMOYNE (1688–1737): *Perseus and Andromeda*. 1723.
London, Wallace Collection.

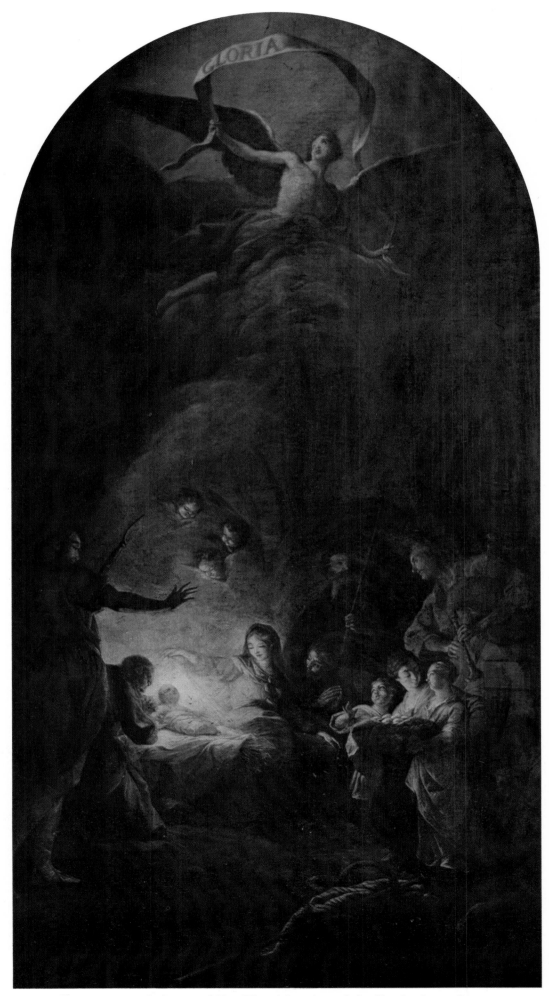

13. JEAN RESTOUT (1692–1768): *The Adoration of the Shepherds*. 1761.
Versailles, Eglise St Louis.

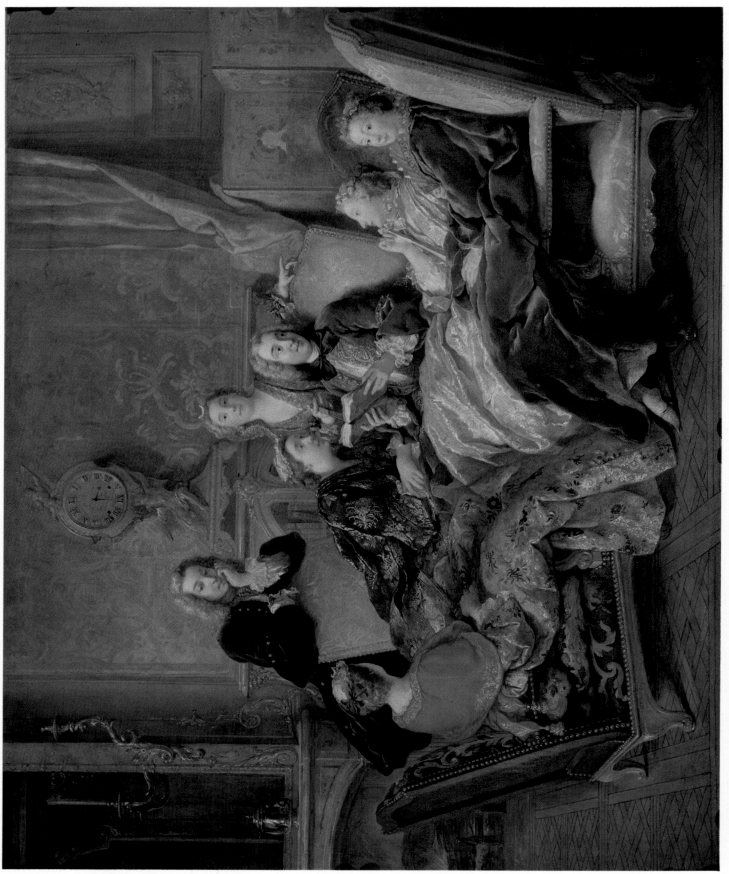

14. JEAN-FRANÇOIS DETROY (1679–1752) : *The Reading from Molière*. About 1728.
Collection of the Dowager Marchioness of Cholmondeley.

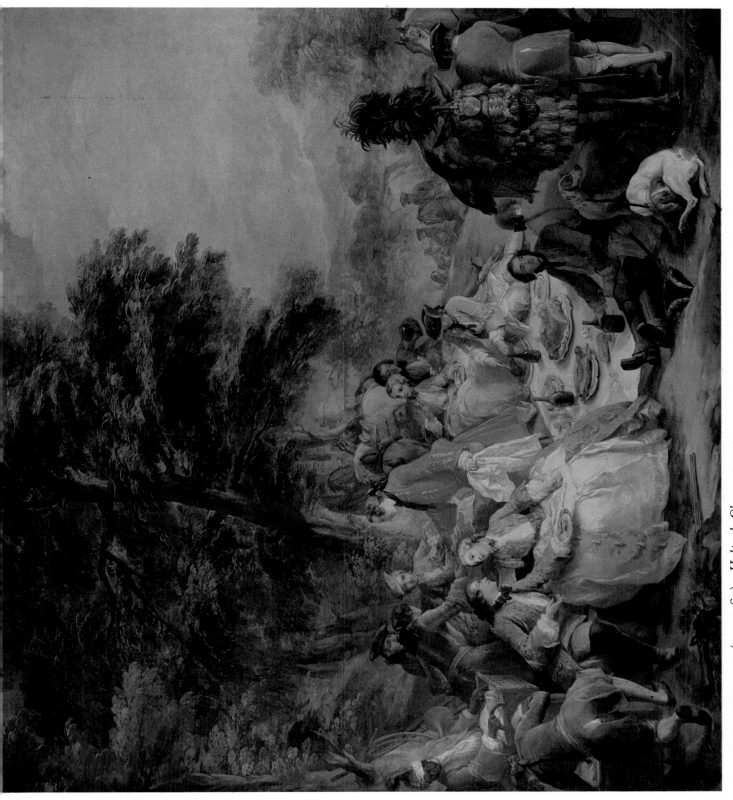

15. CARLE VAN LOO (1705–65): *Halte de Chasse.* 1737.
Paris, Musée du Louvre.

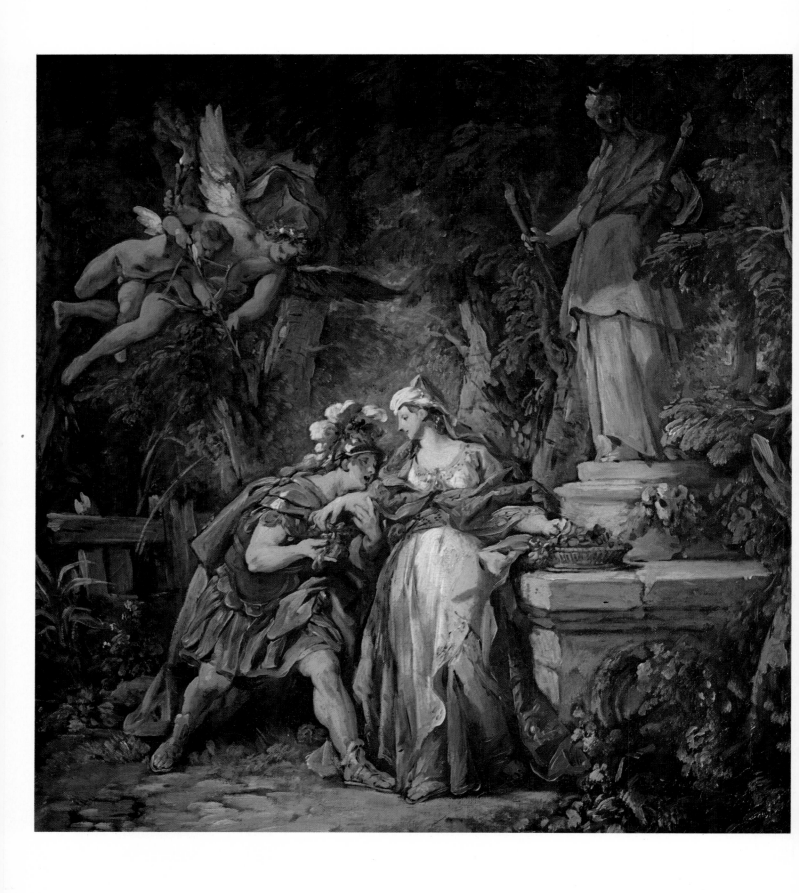

16. JEAN-FRANÇOIS DETROY (1679–1752): *Jason Swearing Eternal Affection to Medea.* 1742–3.
London, National Gallery.

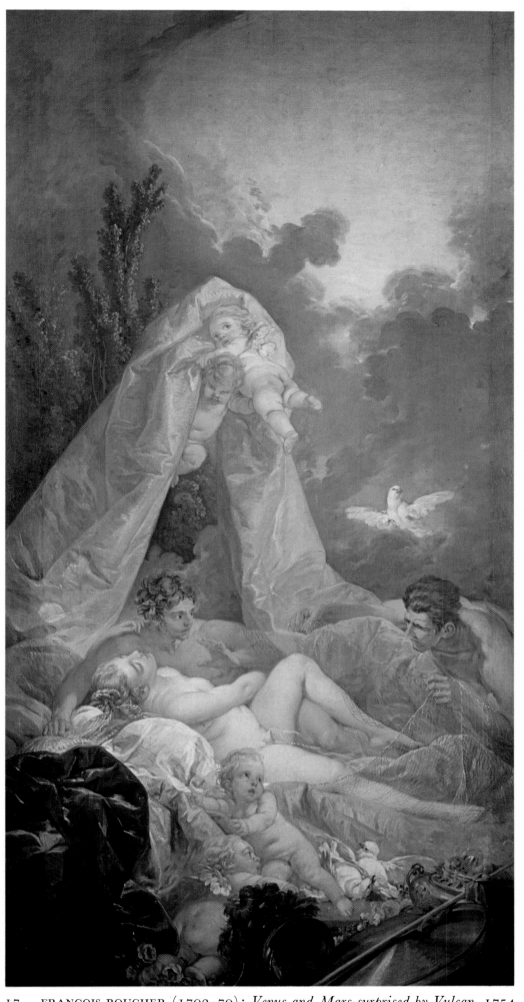

17. FRANÇOIS BOUCHER (1703–70): *Venus and Mars surprised by Vulcan*. 1754. London, Wallace Collection.

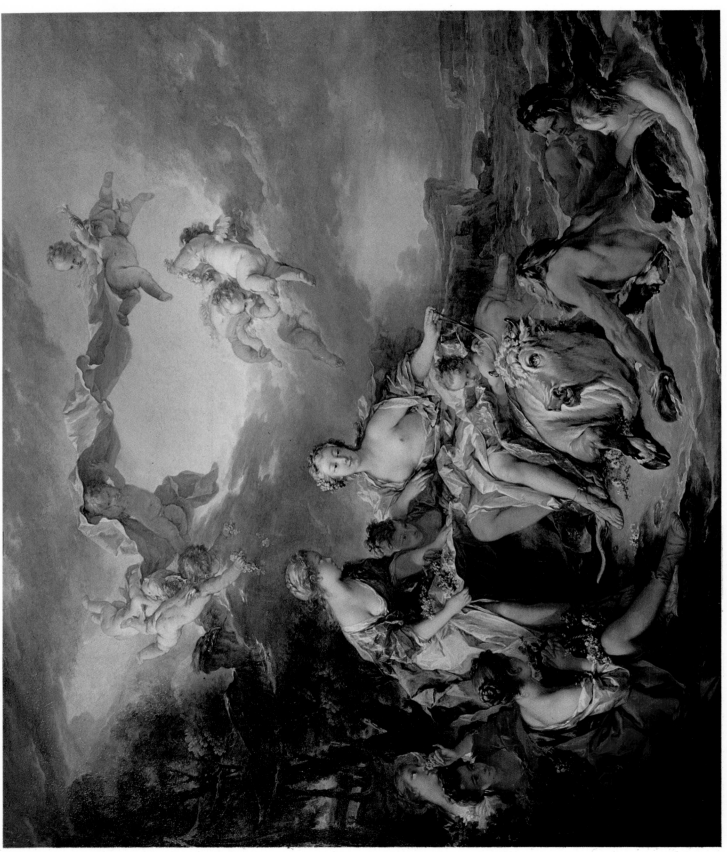

18. FRANÇOIS BOUCHER (1703–70): *The Rape of Europa*. 1747.
Paris, Musée du Louvre.

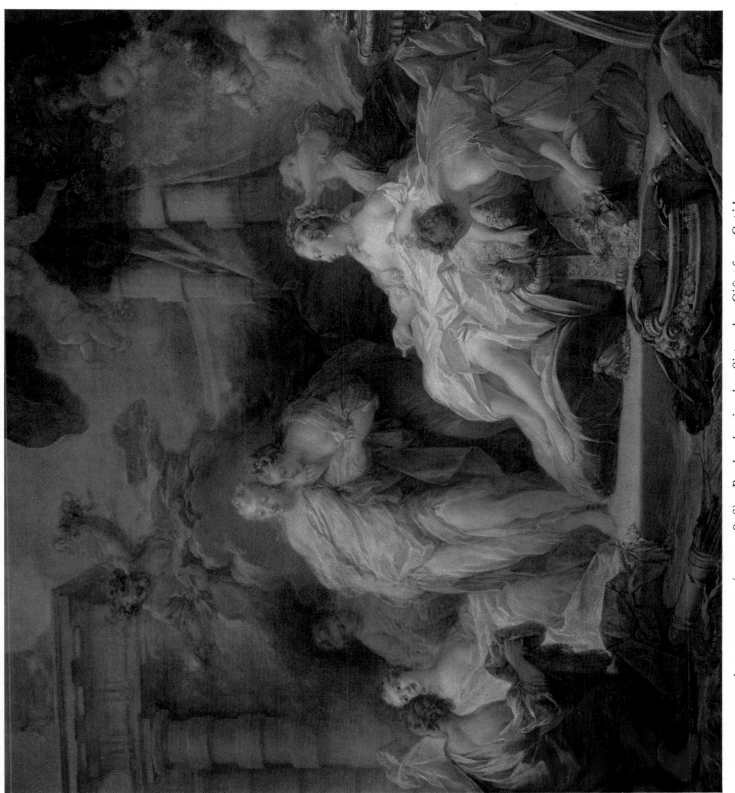

19. JEAN-HONORÉ FRAGONARD (1732–1806): *Psyche showing her Sisters her Gifts from Cupid*. 1753. London, National Gallery.

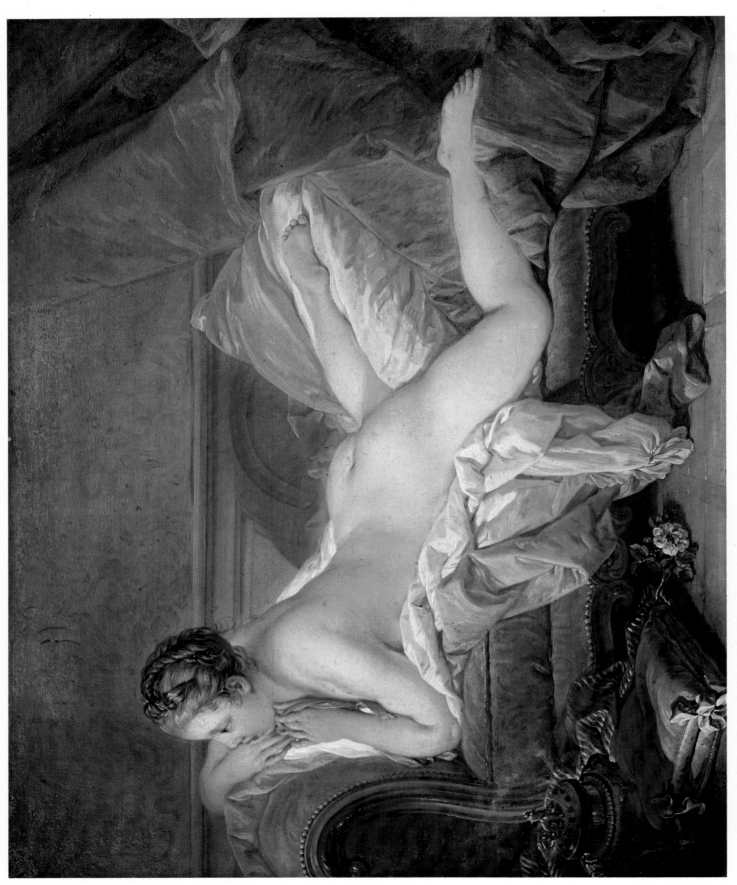

20. FRANÇOIS BOUCHER (1703–70): *Reclining Girl*. 1752. Munich, Alte Pinakothek.

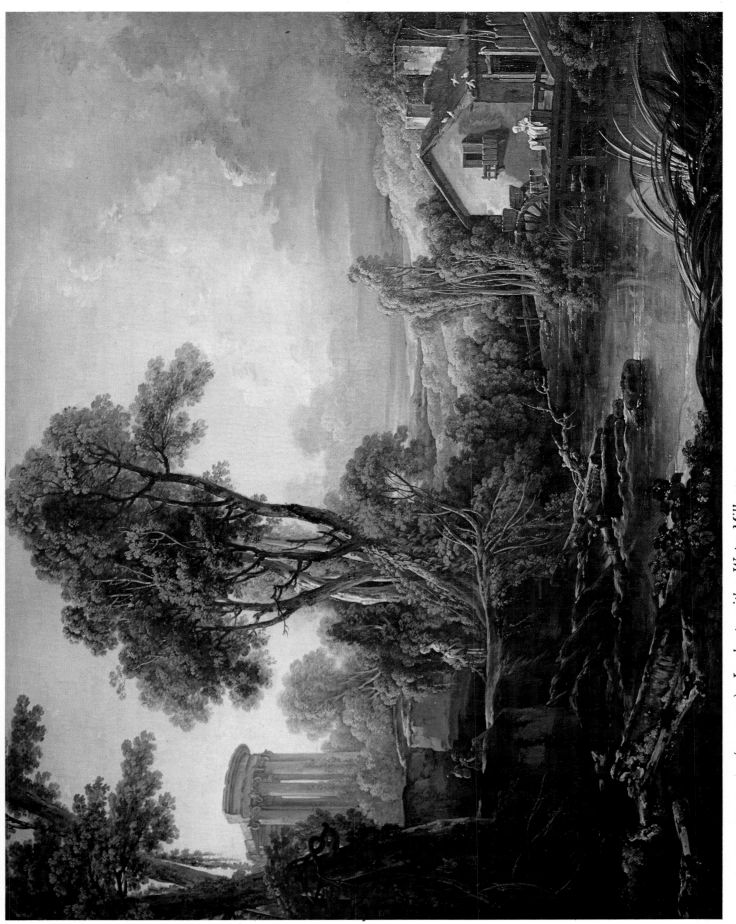

21. FRANÇOIS BOUCHER (1703–70): *Landscape with a Water-Mill*. 1743.
Co. Durham, Barnard Castle, The Bowes Museum.

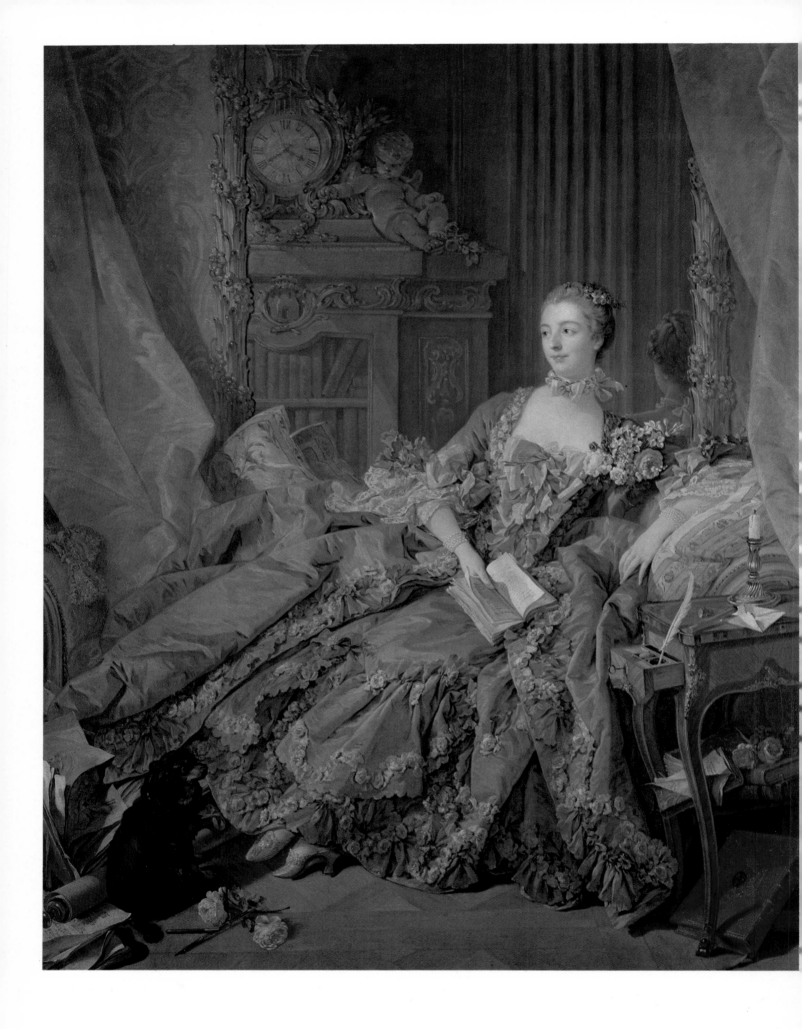

22. FRANÇOIS BOUCHER (1703–70): *Madame de Pompadour*. 1756.
Munich, Alte Pinakothek.

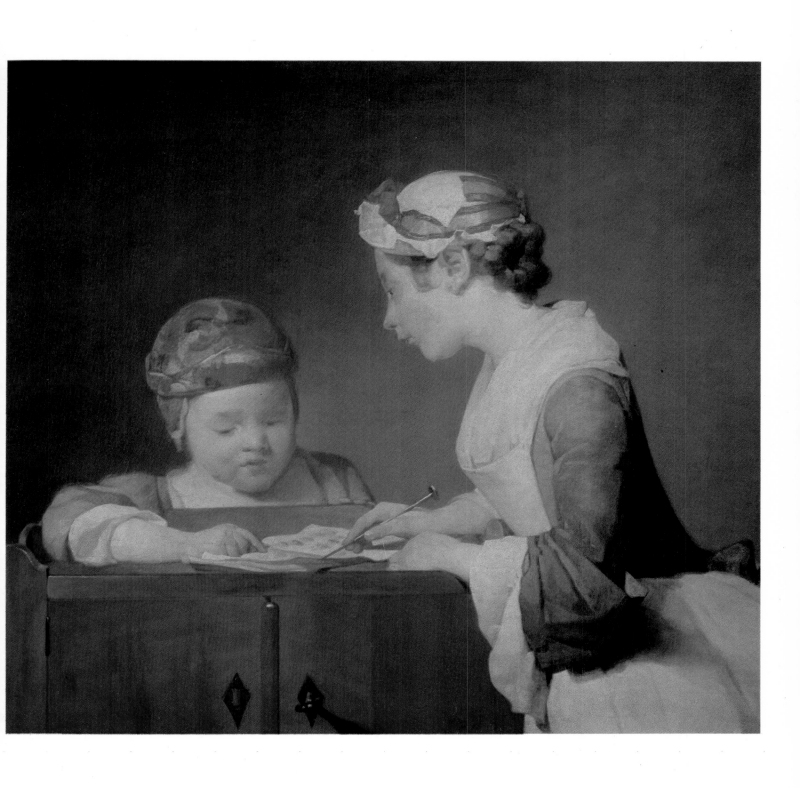

23. JEAN-BAPTISTE SIMÉON CHARDIN (1699–1779): *The Young Schoolmistress*. 1740.
London, National Gallery.

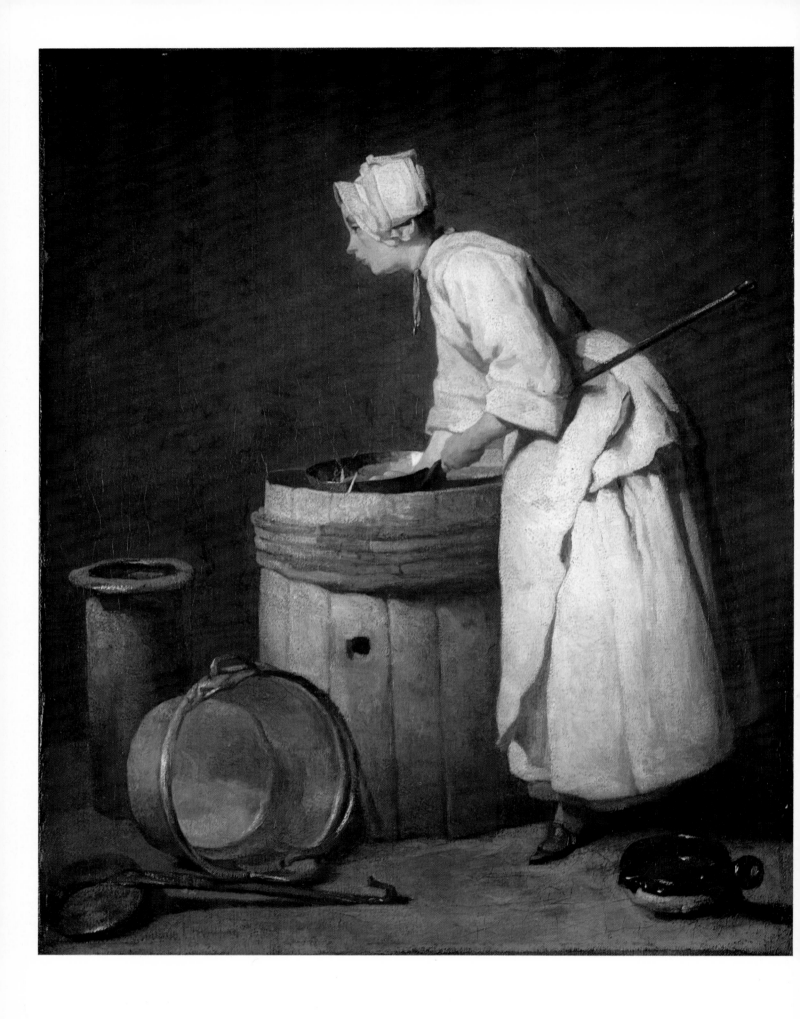

24. JEAN-BAPTISTE SIMÉON CHARDIN (1699–1779): *The Scullery Maid*. 1738.
Glasgow University, Hunterian Collection.

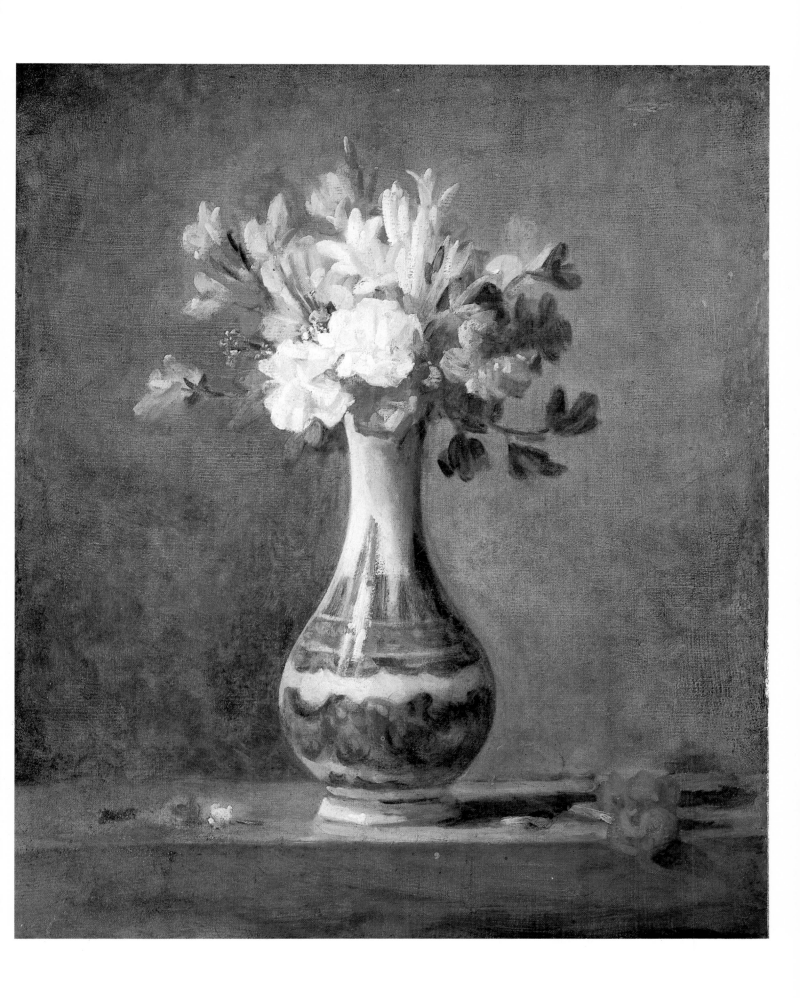

25. JEAN-BAPTISTE SIMÉON CHARDIN (1699–1779): *A Vase of Flowers*. About 1761.
Edinburgh, National Gallery of Scotland.

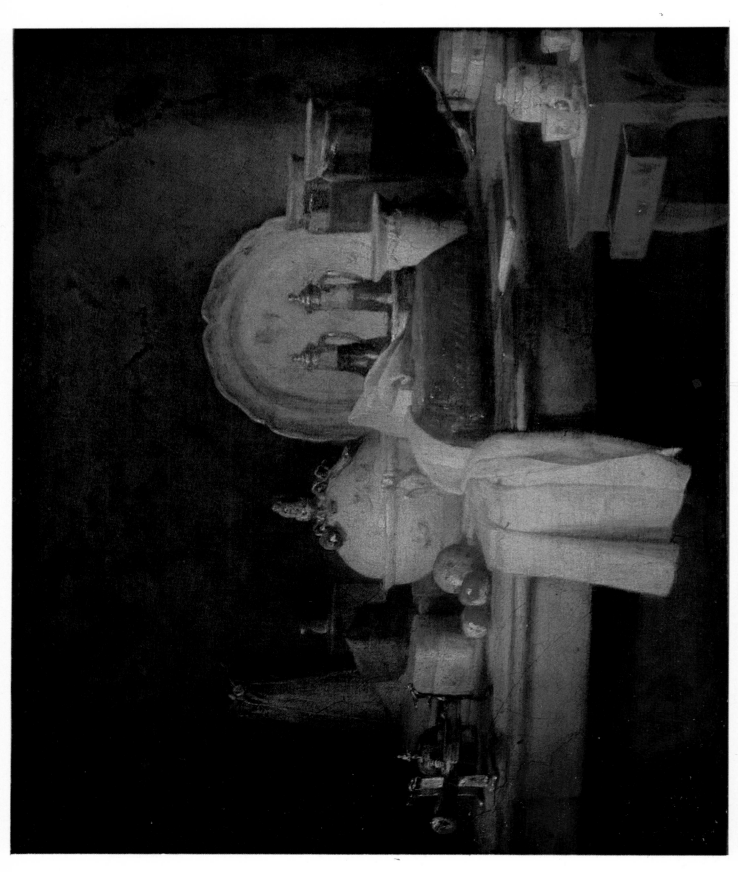

26. JEAN-BAPTISTE SIMÉON CHARDIN (1699–1779): *The Remains of a Meal.* 1763.
Paris, Musée du Louvre.

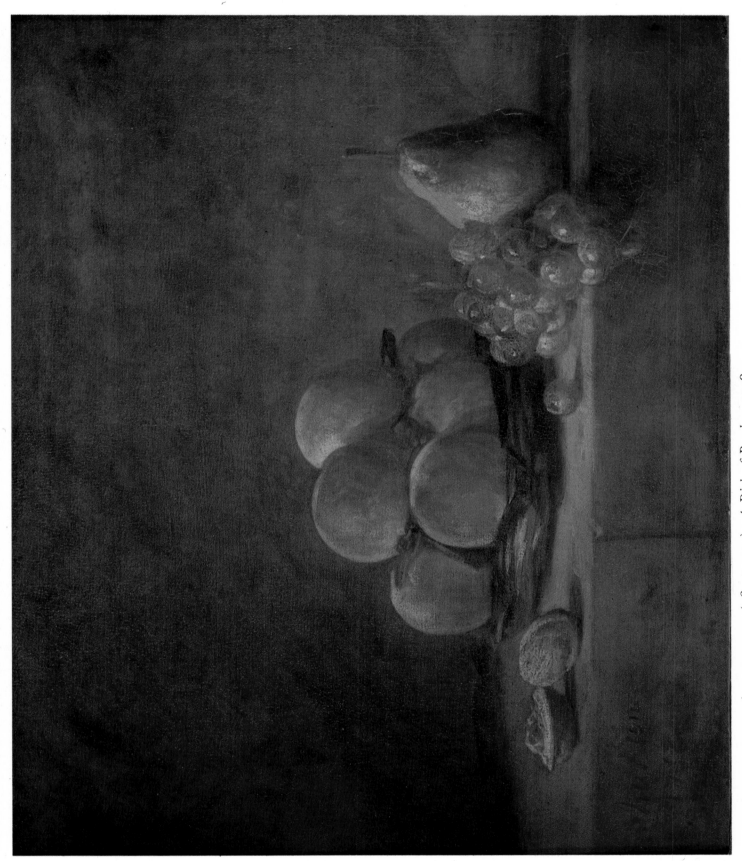

27. JEAN-BAPTISTE SIMÉON CHARDIN (1699–1779): *A Dish of Peaches*. 1758.
Winterthur, Oskar Reinhart Collection.

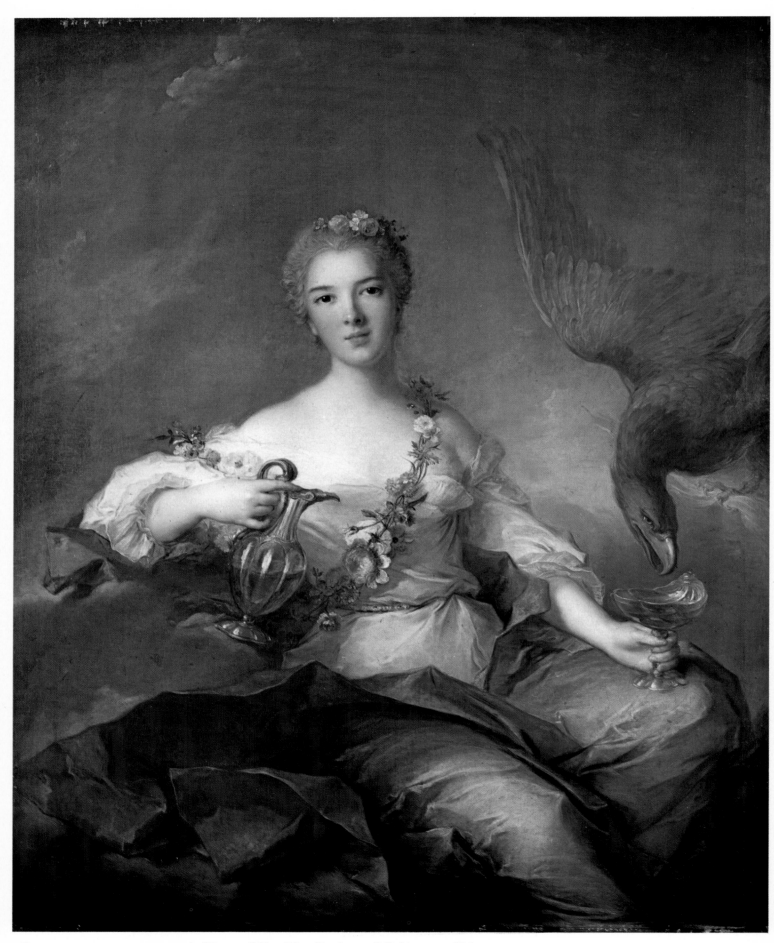

28. JEAN-MARC NATTIER (1685–1766): *The Duchess of Orléans as Hebe.* 1744.
Stockholm, National Museum.

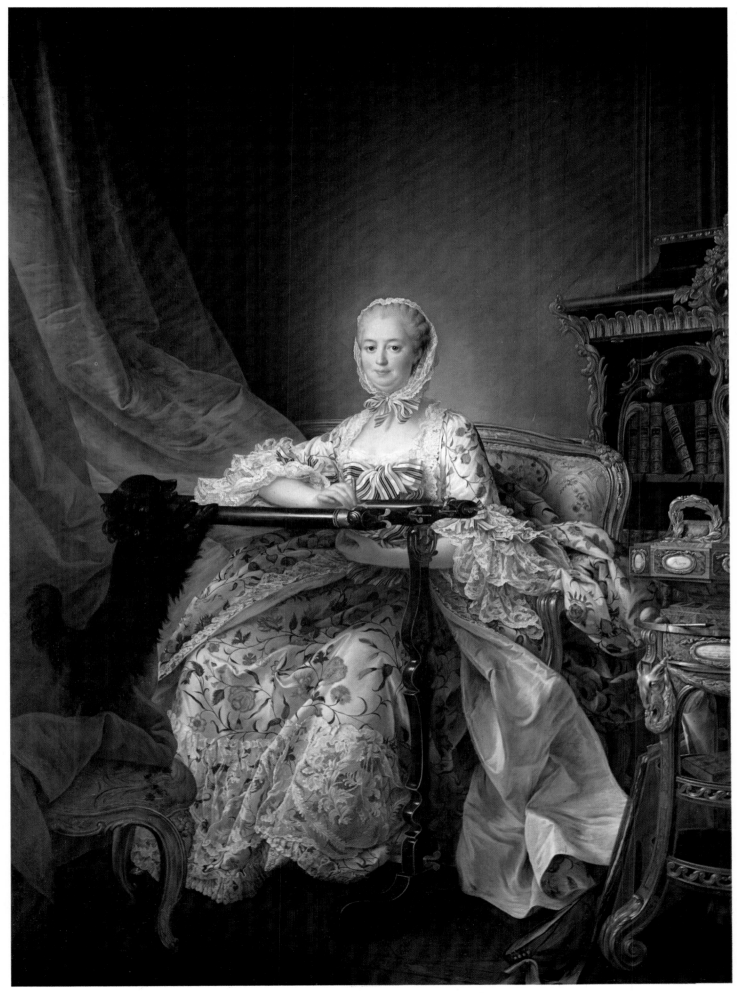

29. FRANÇOIS-HUBERT DROUAIS (1727–75): *Madame de Pompadour.* 1763–4.
London, National Gallery.

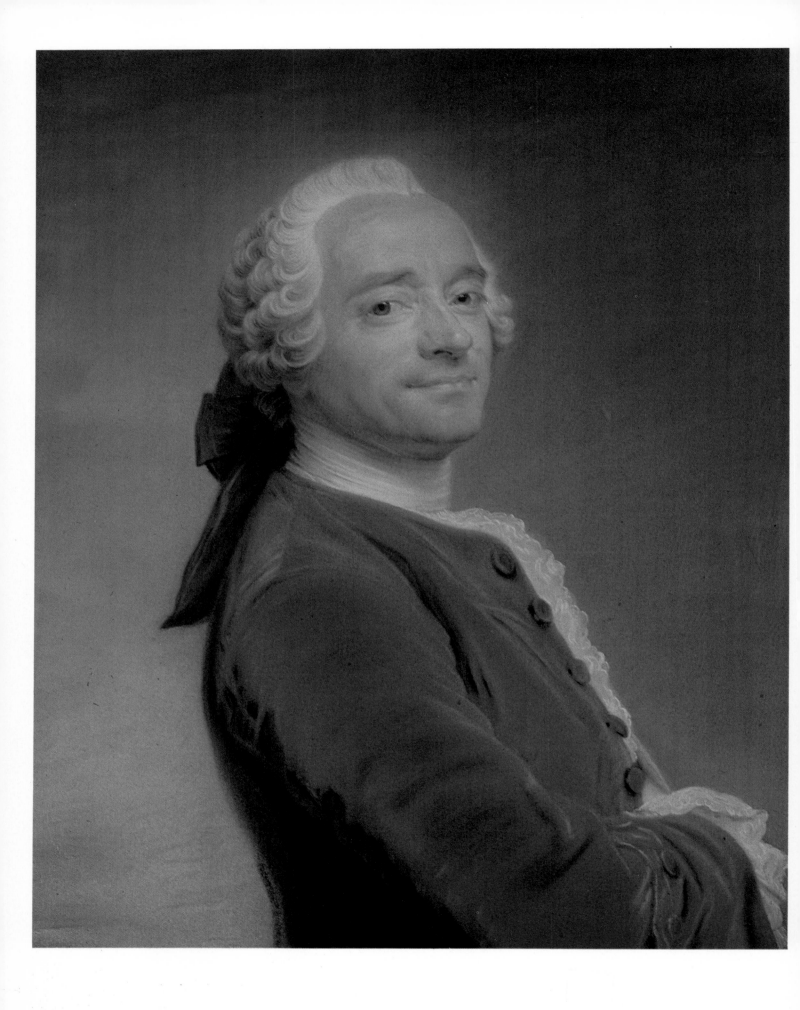

30. MAURICE-QUENTIN DE LA TOUR (1704-88): *Self-Portrait*. About 1760.
Musée d'Amiens.

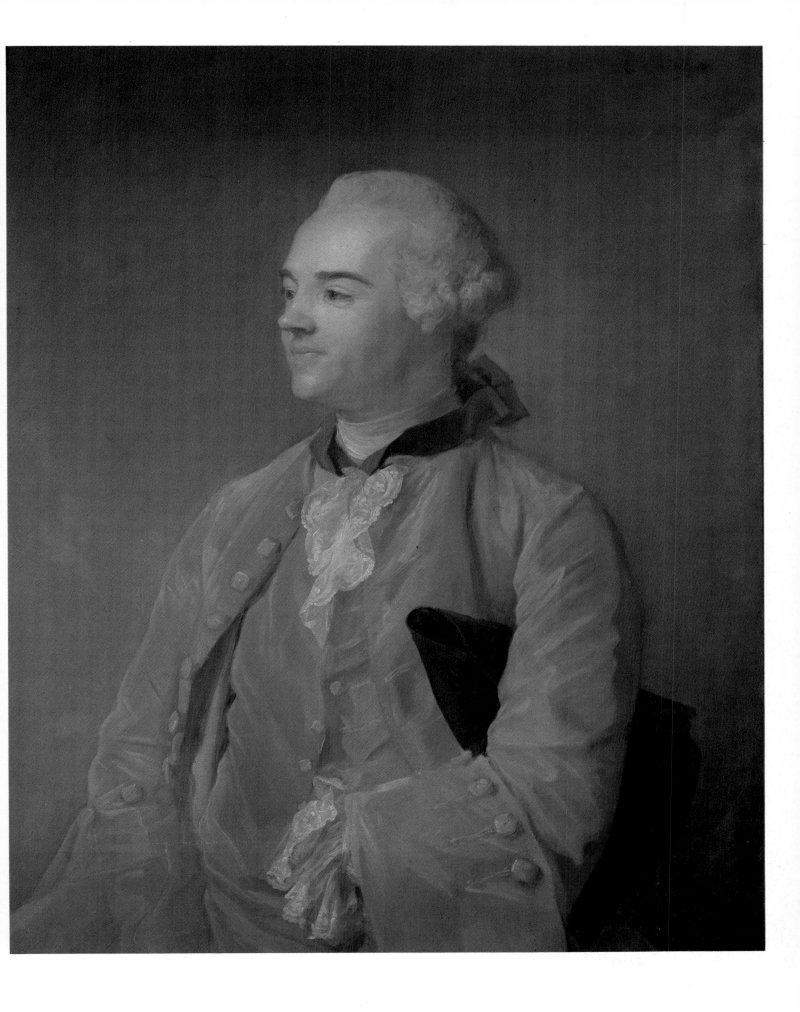

31. JEAN-BAPTISTE PERRONNEAU (?1715–83): *Jacques Cazotte*. About 1760–64.
London, National Gallery.

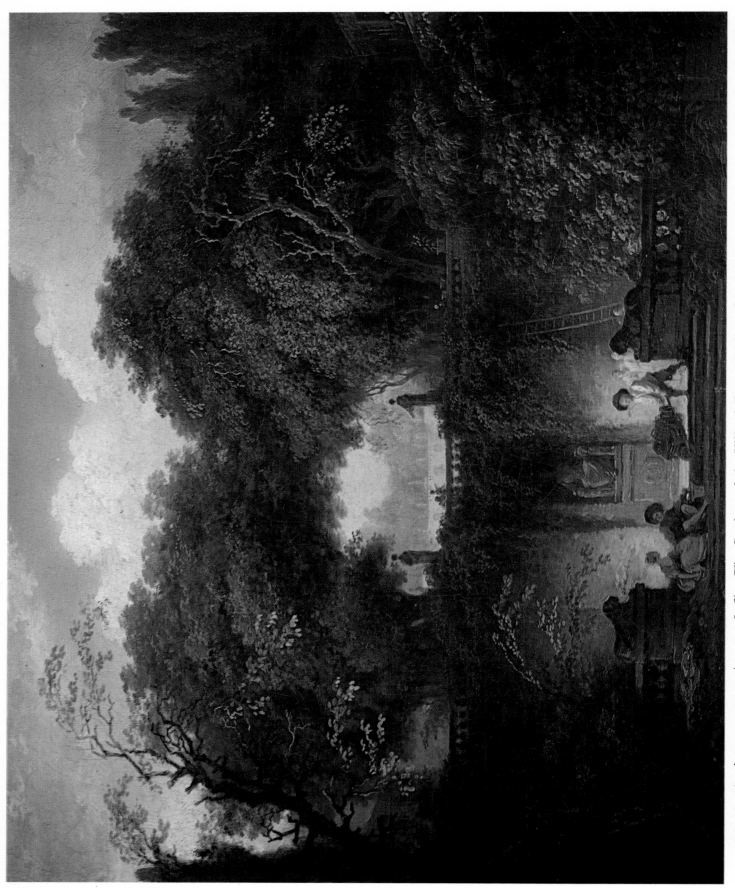

32. JEAN-HONORÉ FRAGONARD (1732–1806): *The Gardens of the Villa d'Este, Tivoli.* 1760.
London, Wallace Collection.

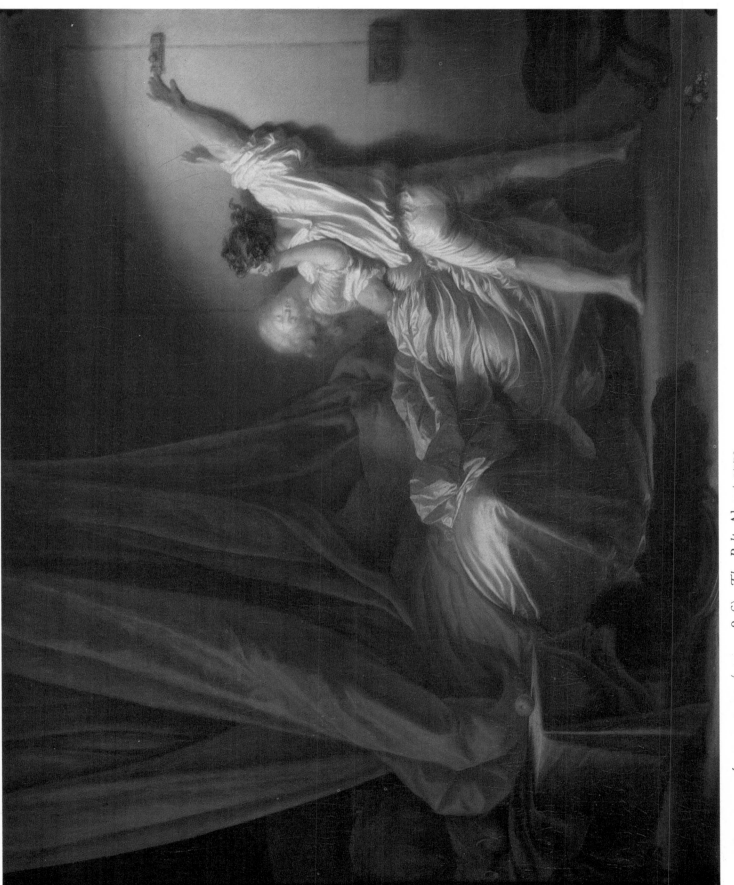

33. JEAN-HONORÉ FRAGONARD (1732–1806): *The Bolt*. About 1779. Paris, Musée du Louvre.

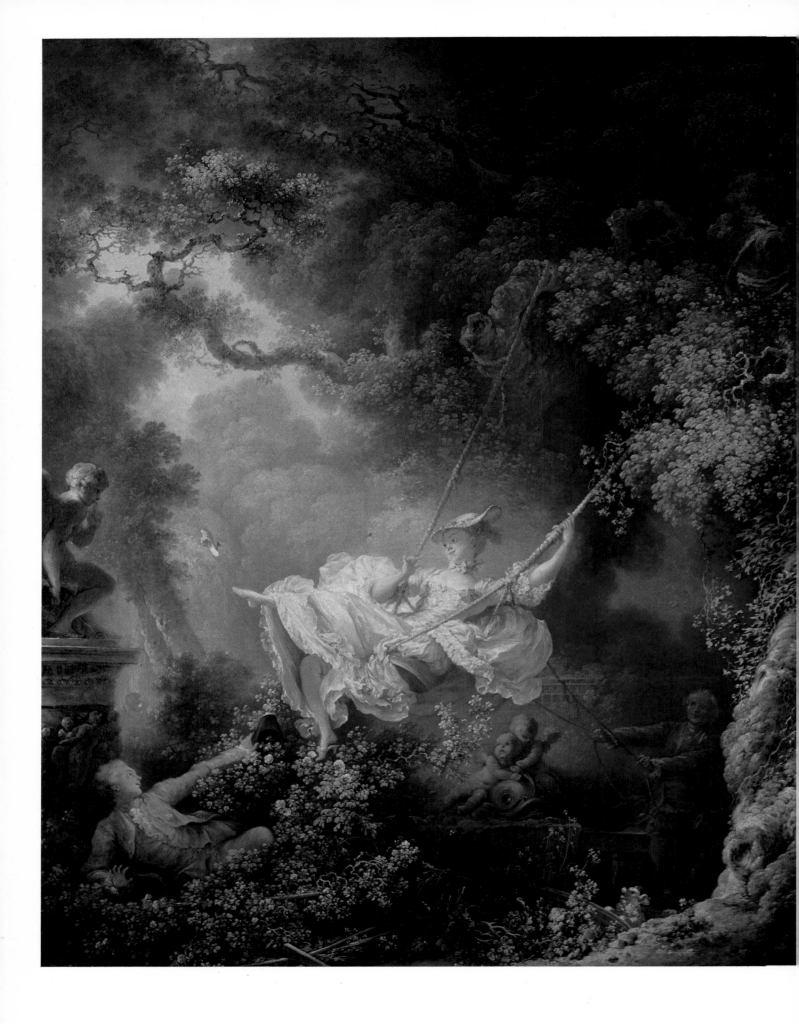

34. JEAN-HONORÉ FRAGONARD (1732–1806): *The Swing*. 1768–9.
London, Wallace Collection.

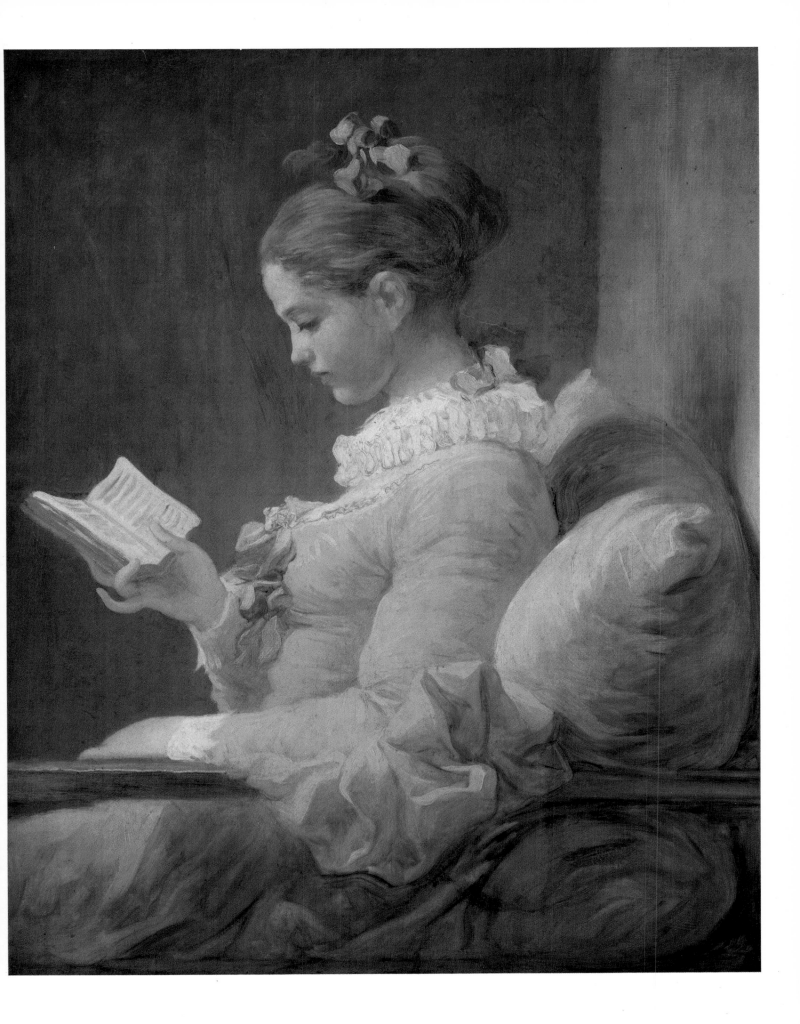

35. JEAN-HONORÉ FRAGONARD (1732–1806): *Woman Reading a Book*. About 1775.
Washington D.C., National Gallery of Art.

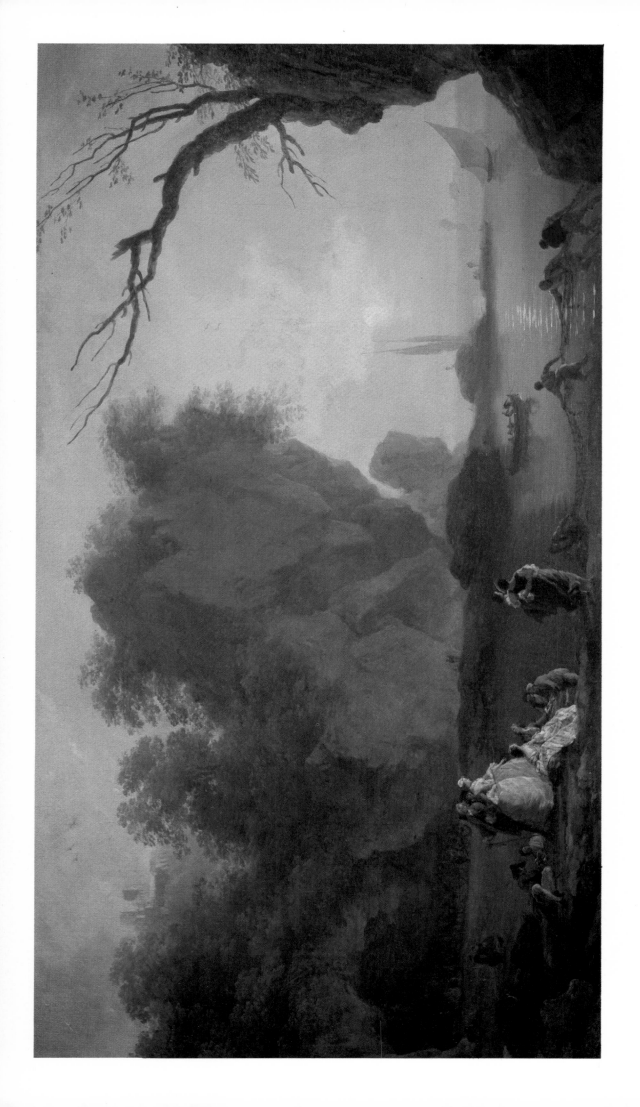

36. CLAUDE-JOSEPH VERNET (1714–89): *View over a Bay*. About 1742.
London, Wellington Museum.

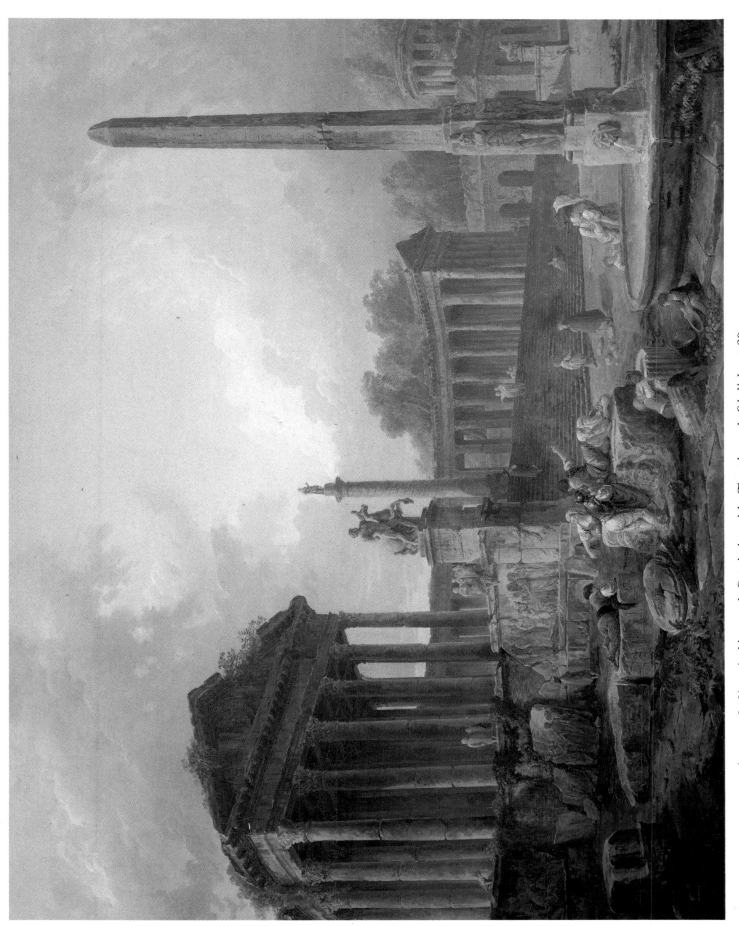

37. HUBERT ROBERT (1733–1808): *Architectural Capriccio with Temple and Obelisk*. 1768. Co. Durham, Barnard Castle, The Bowes Museum.

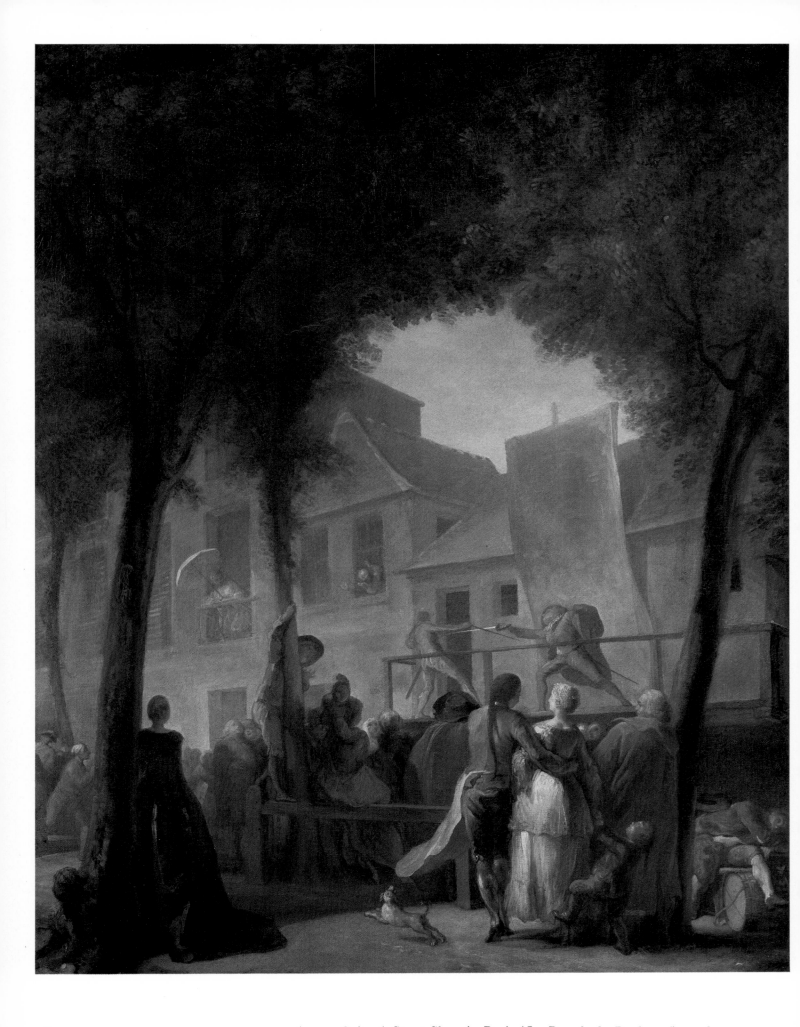

38. GABRIEL-JACQUES DE SAINT-AUBIN (1724–80): *A Street Show in Paris* (*La Parade du Boulevard*). 1760.
London, National Gallery.

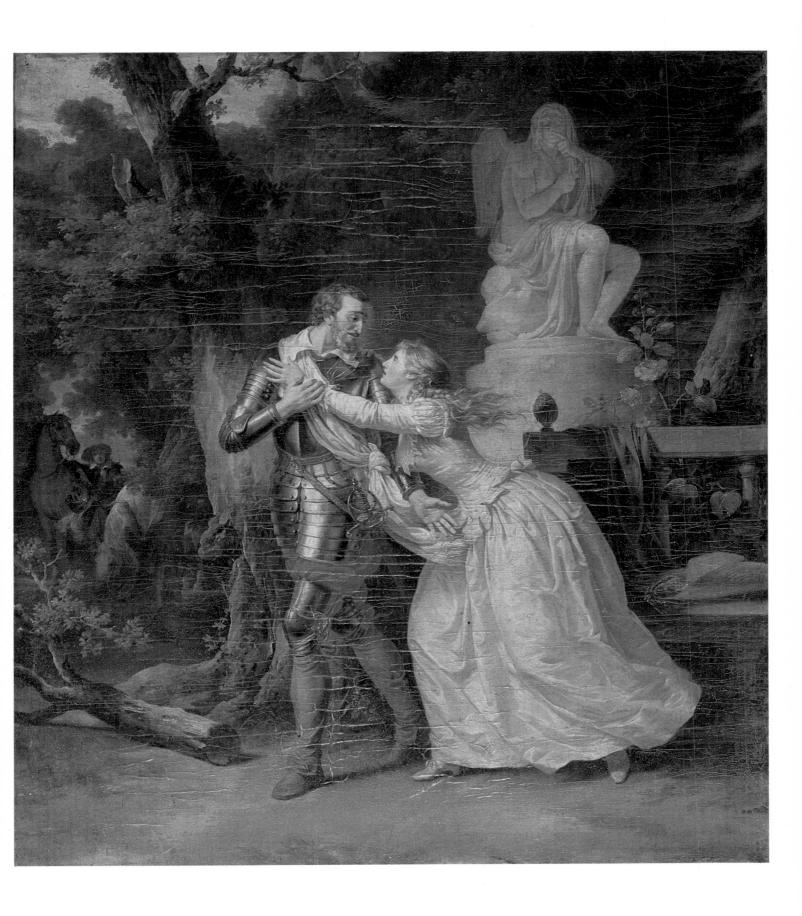

39. FRANÇOIS-ANDRÉ VINCENT (1746–1816): *Le Rendez-vous (Henri IV and Gabrielle d'Estrées)*. 1783–7.
Musée de Fontainebleau.

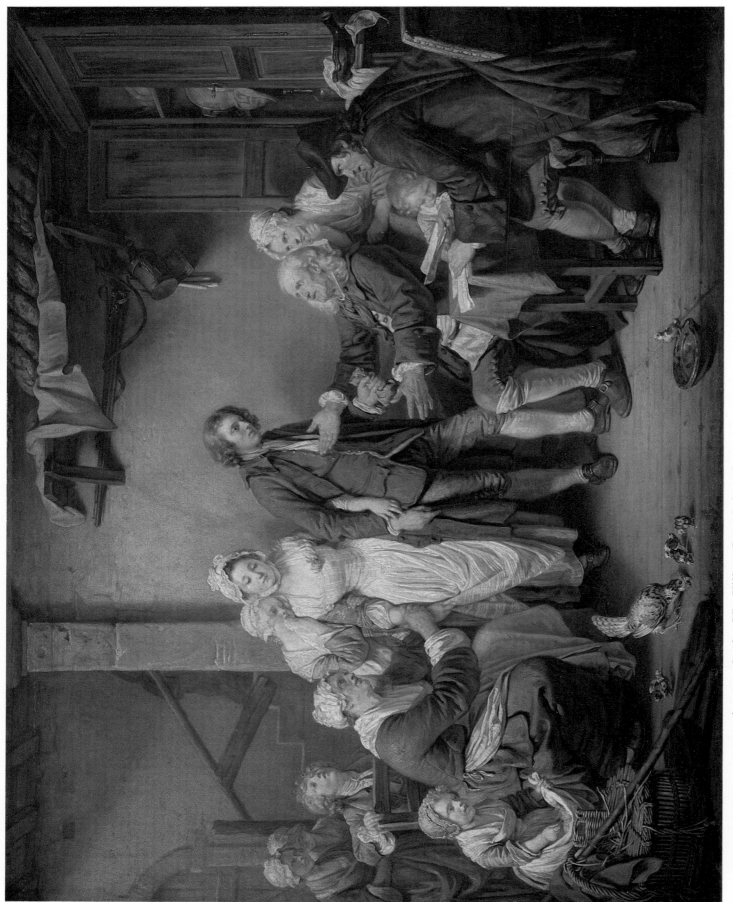

40. JEAN-BAPTISTE GREUZE (1725–1805): *The Village Betrothal*. 1761.
Paris, Musée du Louvre.

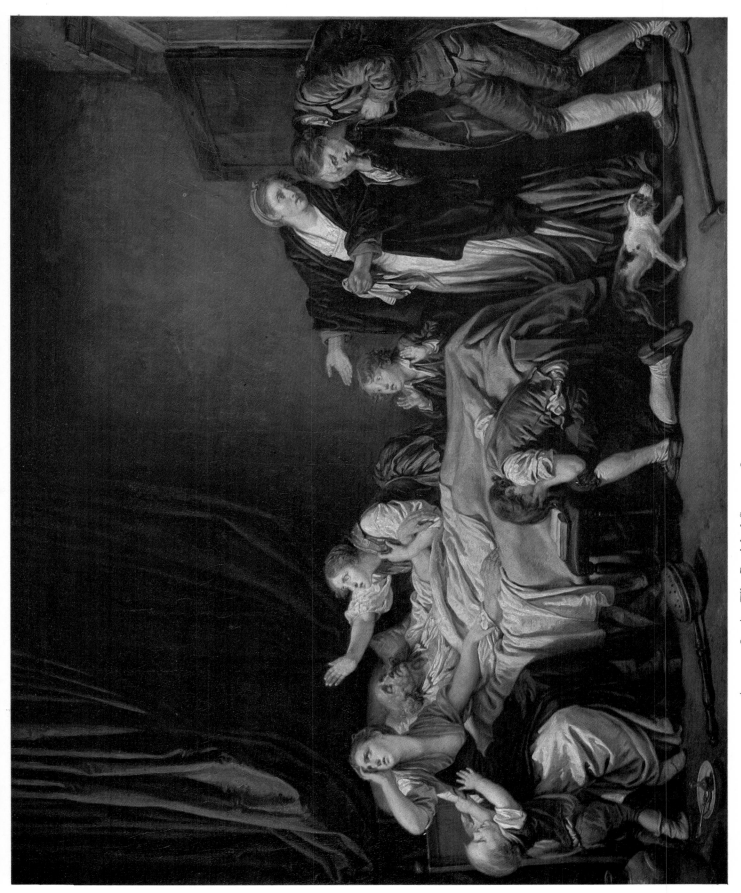

41. JEAN-BAPTISTE GREUZE (1725–1805): *The Punished Son*. 1778.
Paris, Musée du Louvre.

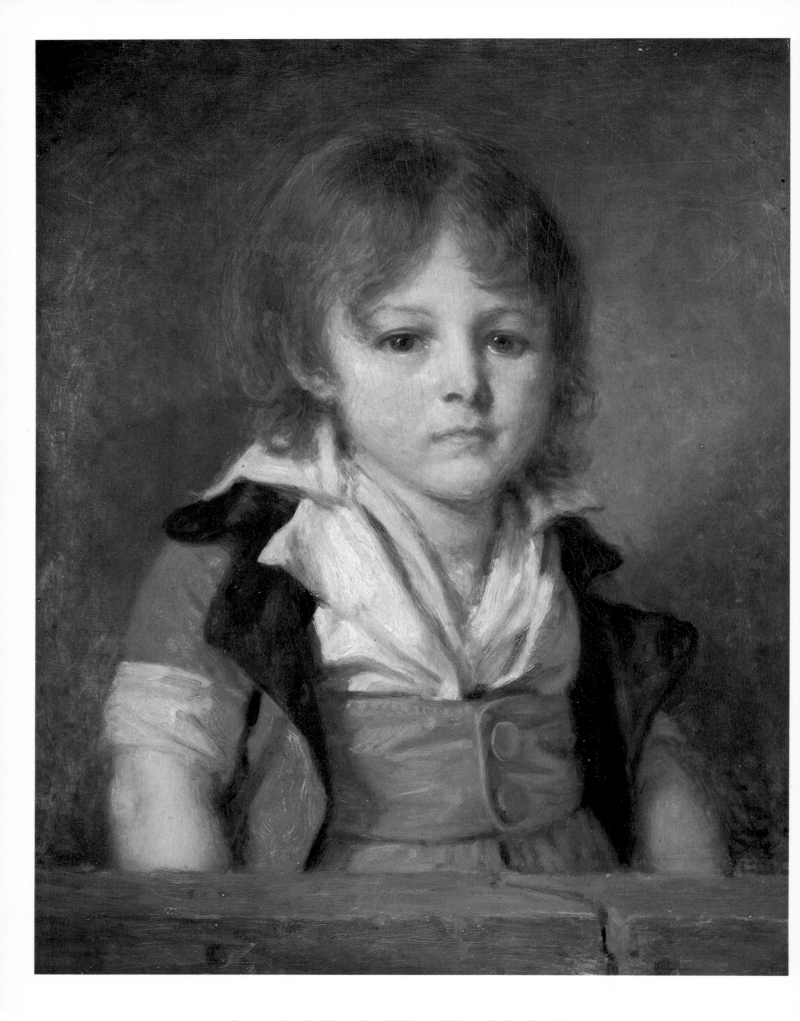

42. JEAN-BAPTISTE GREUZE (1725–1805): *Portrait of Edouard-François Bertin*. About 1800.
Paris, Musée du Louvre.

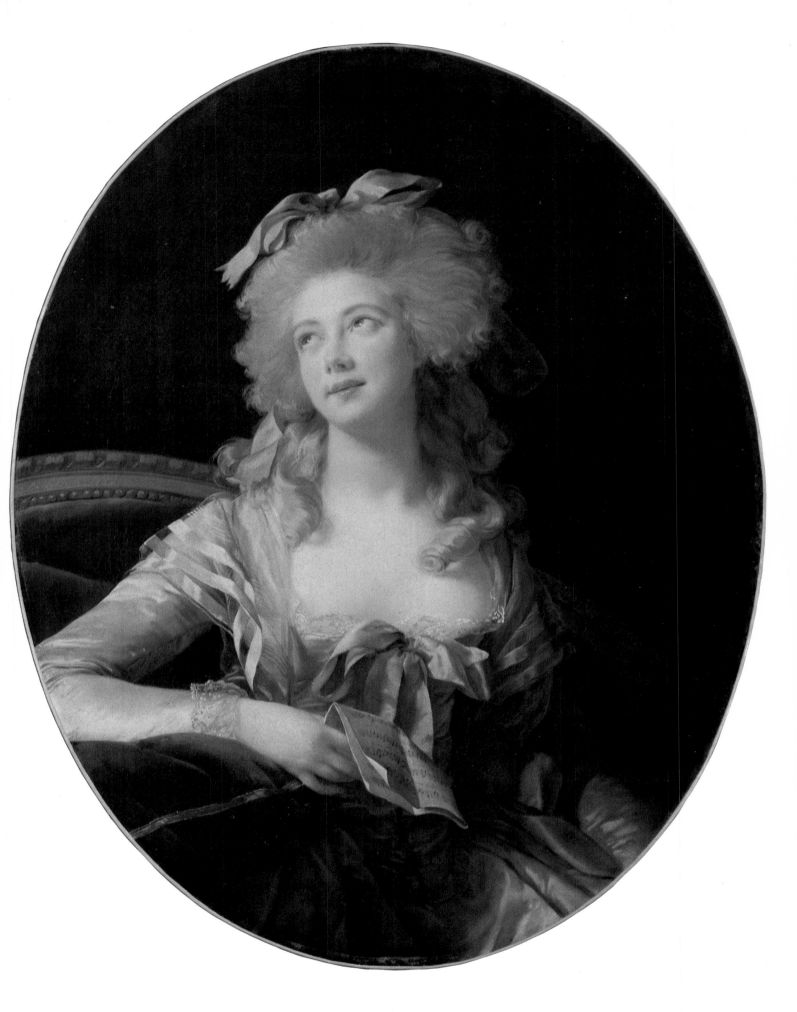

43. LOUISE-ÉLISABETH VIGÉE-LEBRUN (1755–1842): *Madame Grand, later Princesse de Talleyrand*. 1783. New York, Metropolitan Museum of Art.

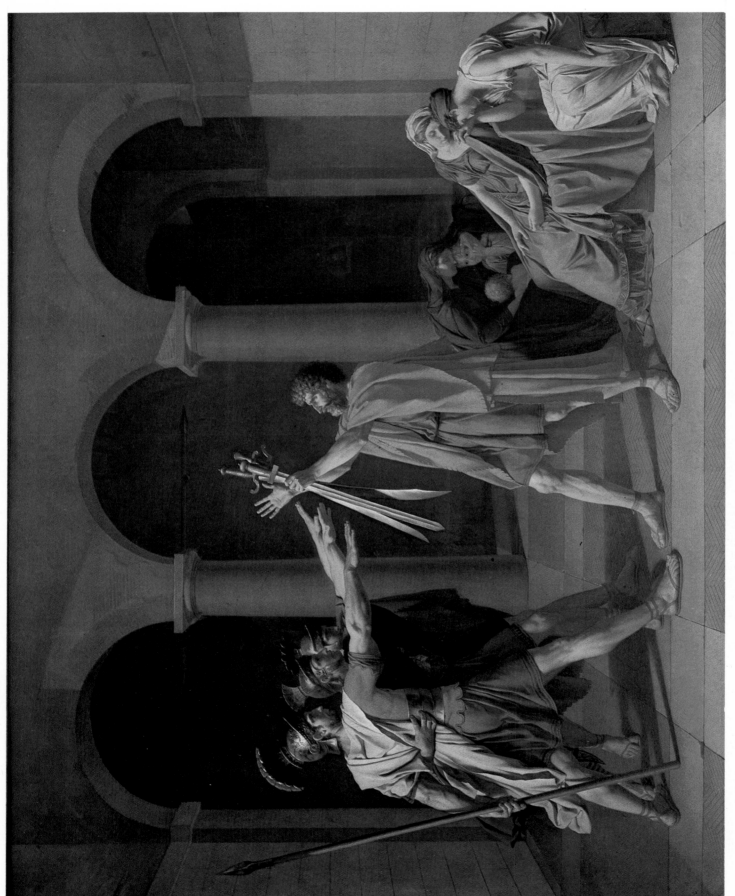

44. JACQUES-LOUIS DAVID (1748–1825): *The Oath of the Horatii.* 1784. Paris, Musée du Louvre.

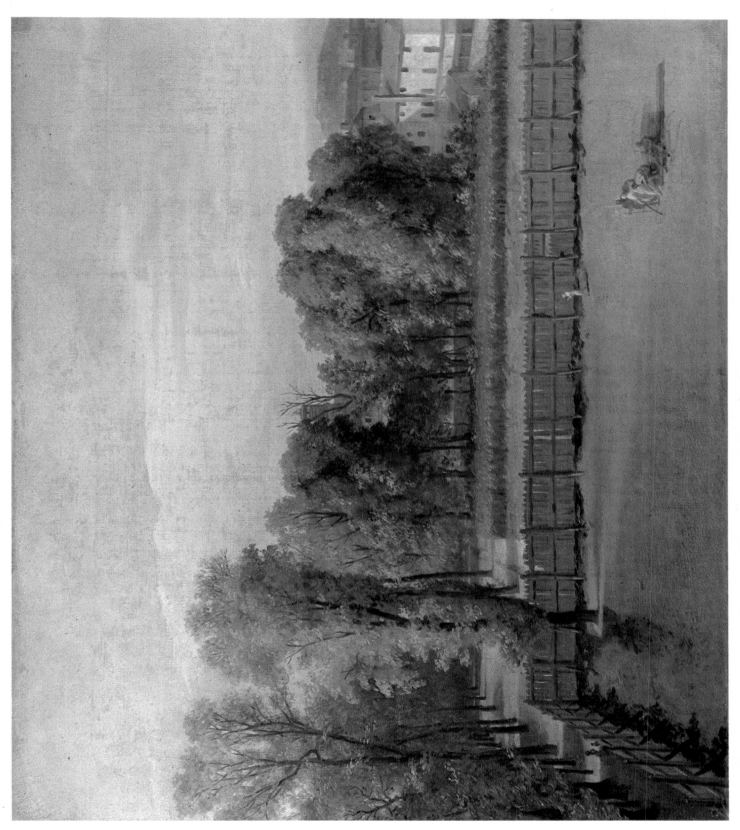

45. JACQUES-LOUIS DAVID (1748–1825): *View in the Luxembourg Gardens*. 1794.
Paris, Musée du Louvre.

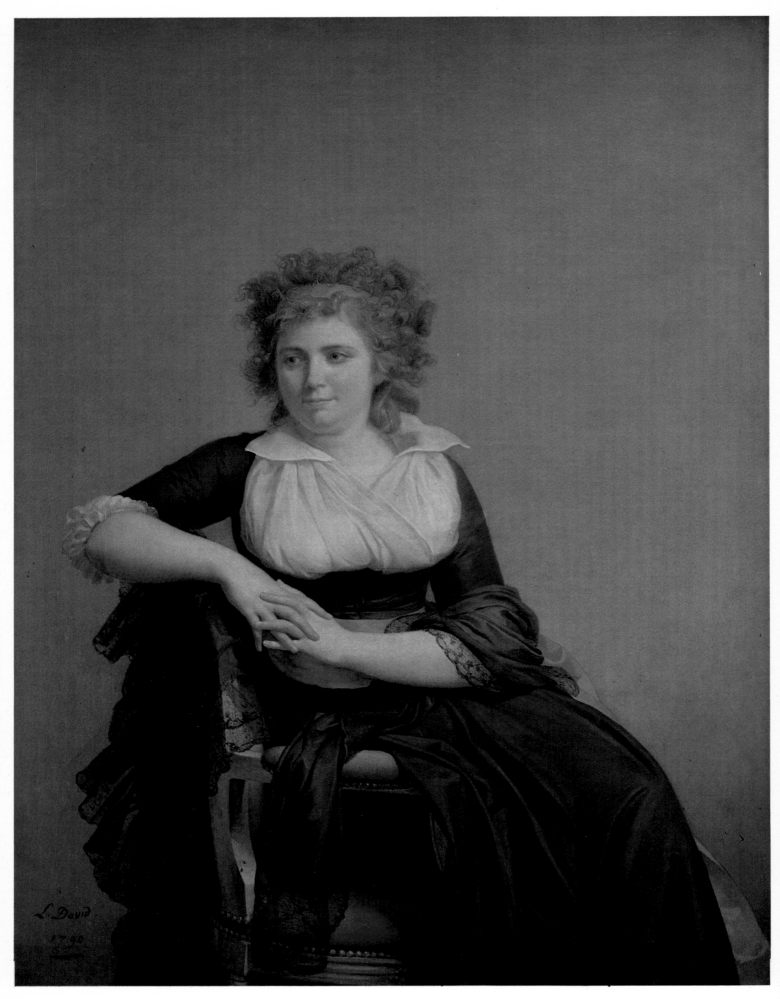

46. JACQUES-LOUIS DAVID (1748–1825): *The Marquise d'Orvilliers*. 1790.
Paris, Musée du Louvre.

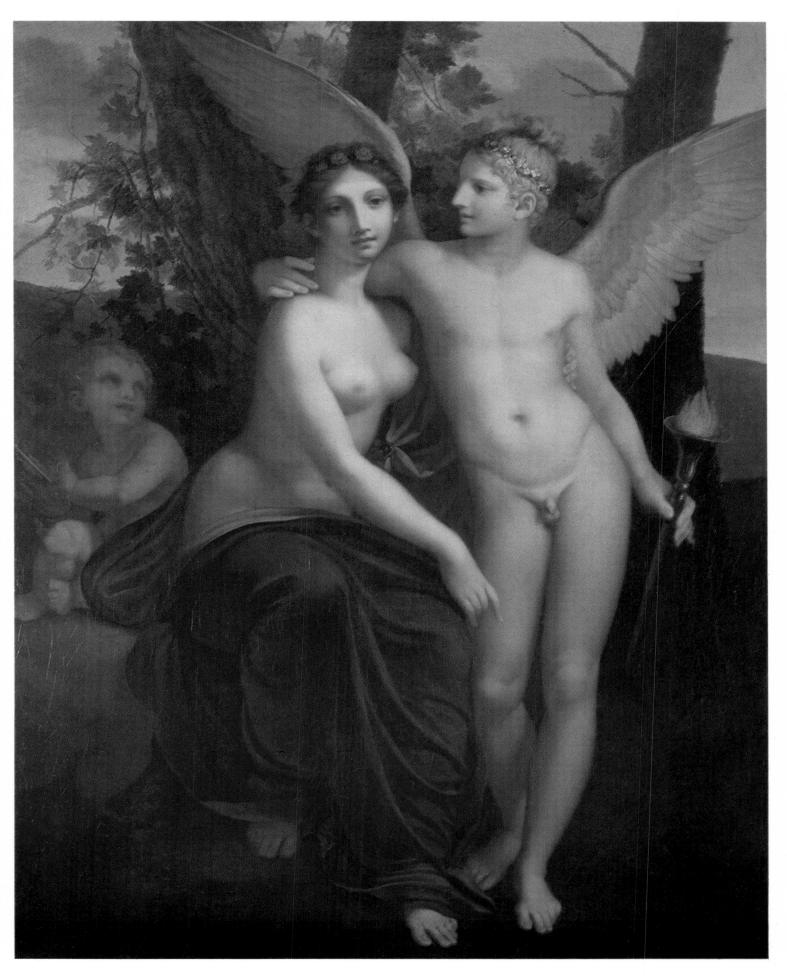

47. PIERRE-PAUL PRUD'HON (1758–1823): *The Union of Love and Friendship*. 1793.
Minneapolis Institute of Arts.

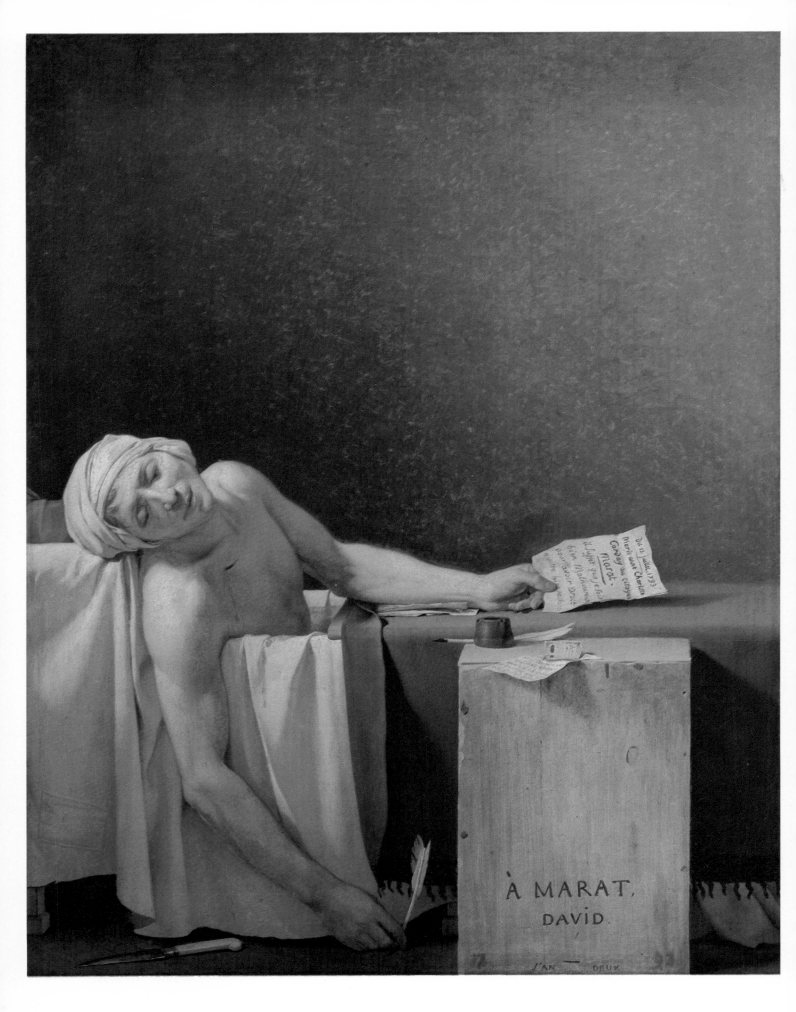

48. JACQUES-LOUIS DAVID (1748–1825): *The Dead Marat.* 1793.
Brussels, Musées Royaux des Beaux-Arts de Belgique.